The Museum of Kitschy Stitches

A Gallery of Notorious Knits

By Stitchy McYarnpants

QUIRK BOOKS

PHILADELPHIA

A Sockit Projects book

Library of Congress Cataloging in Publication Number: 2006920609

ISBN-10: 1-59474-111-5
ISBN-13: 978-1-59474-111-1

Printed in China

Typeset In: ITC Avant Garde Gothic
Designed By: Arin LoPrete & Stephen Conti

Distributed in North America by Chronicle Books
85 Second Street
San Francisco, CA 94105

10 9 8 7 6 5 4 3 2

Quirk Books
215 Church Street
Philadelphia PA 19106
www.quirkbooks.com

Contents

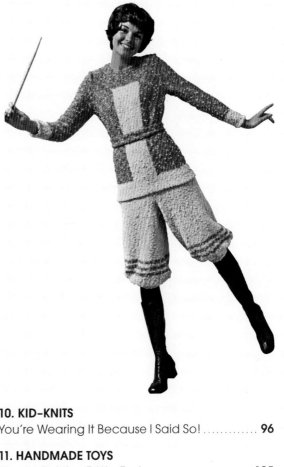

INTRODUCTION ... 4

1. HOODWINKED
Never Trust a Homemade Hat 7

**2. YOU KNIT FOR YOUR MAMA
WITH THOSE NEEDLES?**
Bad Girls, Worse Outfits 18

3. YOUR WORST KNITMARE
A Horror Show of Faux Fur Monstrosities 30

4. WELCOME TO POLYESTERYEAR
An Age of Unforgivable Synthetics 39

5. DRESS FOR SUCK-CESS
Frocks That Shock 48

6. GLAMMA!
Acrylic Couture for Klassy Knitters 57

7. EMASCULATION NATION
Menswear That Makes Men Swear 67

8. GRANNY SQUARES EVERYWHERE
Grandma's Sweet Revenge 80

9. IT'S A CLOWN'S WORLD
A Creepy Peek at the
Clownterculture of Crafts........................... 89

10. KID-KNITS
You're Wearing It Because I Said So! 96

11. HANDMADE TOYS
How to Put the *F-U* in *Fun*! 105

12. HOUSE OF YARN
Home Is Where the Homely Is 114

SPECIAL BONUS PATTERNS 123

ABOUT THE AUTHOR 128

Introduction

I HAVE A CONFESSION TO MAKE.

I have an unnatural urge to buy every vintage craft pattern I see. Is that pile of empty bleach bottles taking over the laundry room? There's a booklet that'll teach you how a little felt and some sequins can transform a bottle into a unique and terrifying pet. Do you have too much silverware and not enough jewelry? I have a book that will show you how to make a simple fork fit for a glamorous night on the town. And if you're not going to be using the rest of those L'eggs pantyhose containers, I can help you furnish your entire house.

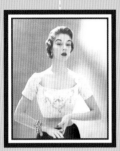

But what I love best are knitting and crocheting patterns. I have piles of them, from the roaring '20s all the way to the whimpering '80s. The wasp-waisted models of the '50s seem to purr as sleek knit dresses hug their sharp, pointy figures. The groovy gals of the '60s took on a decidedly softer texture when they rejected bullet bras and whalebone corsets in favor of letting it all hang out in minidresses and go-go boots. And up until the '70s, men's patterns typically featured gents holding either a cigarette or a pair of skis. Sometimes both. It's nice that they didn't let the argyle interfere with their manly pursuits.

I have patterns for everything from lace table runners to fishnet stockings, from fancy to floozy and everything in between. There was even a brief novelty potholder phase that culminated in my going cold turkey from eBay for almost six months. Let us not speak of it again.

Among my vast collection are a great number of tasteful patterns that could pass for modern fashion—the classic cut of a mid-century cardigan or a delicate lace shawl are always delightful additions to any wardrobe. And then there are the patterns that time only wishes it could forget. Alas, there are not enough banana daiquiris in the world to erase what we've seen emerge from the fickle maw of handcrafted fashion over the years. Images of crocheted pantsuits, belted vests, and peppy poodle toilet paper covers are burned into society's memory forever.

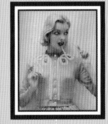

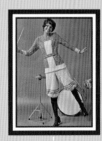

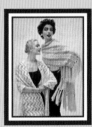

What is it that makes some patterns so gleefully awful? It turns out that there's a wide array of elements that go into bad design. Some are ill-fitting and cause discomfort merely by looking at them. Others are recklessly embellished with pockets in mysterious places, colors juxtaposed in flagrant disregard of reason, and bizarre textures where none should be. Tassels are often involved. But certainly the most common ingredient is entirely avoidable: crappy yarn. Sure, petroleum products are great; they help us all in our everyday lives. Better living through chemicals and all of that. But while garbage cans are happily made of sturdy plastic, sweaters should not be.

Acrylic yarn does have its place, and it can be very soft when extracted from the earth's crust properly. It can even look all right if it's made in attractive colors. But one only need look to the 1970s, the height of the Acrylic Age, to see that when yarn has neither softness nor attractive coloration, it acquires the essence of its original state: prehistoric turds.

Which brings us to *The Museum of Kitschy Stitches*, a collection of the most groan-inspiring crimes against hand-crafted fashion ever to assault the senses. Their designers would have us believe that granny squares can be used for anything, that men look good in ponchos, and that you can (and should) make a clown out of just about anything. Whether it's sci-fi inspired headwear from the '40s, gender-bending sweater sets from the '60s, or pretty much anything from the '70s, these eye-piercing styles have an allure all their own. It is these patterns that have inspired me. If you find the wanton misuse of sticks and yarn irresistible, prepare to be dazzled, dizzied, and eventually disoriented.

HOODWINKED

NEVER TRUST A HOMEMADE HAT

There are as many types of hats as there are occasions. Party hats, Easter bonnets, cervical caps, you name it! They're a classic accoutrement that no closet should be without. And since your closet is already full of hand-knit atrocities, why not accessorize them? From berets to babushkas, sombreros to stovetops, nothing says "Get a load of me!" like a homemade headpiece.

So gather up all that yarn left over from your granny-square pantsuit and get stitching. Whether you go for a fez or a fedora or an unholy mutation of the two, remember: The right chapeau can add a special touch to any outfit, and the wrong one can beat it into submission. Choose carefully, for in the turbulent waters of fashion, the fish stinks from the head down.

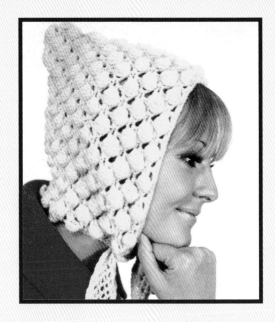

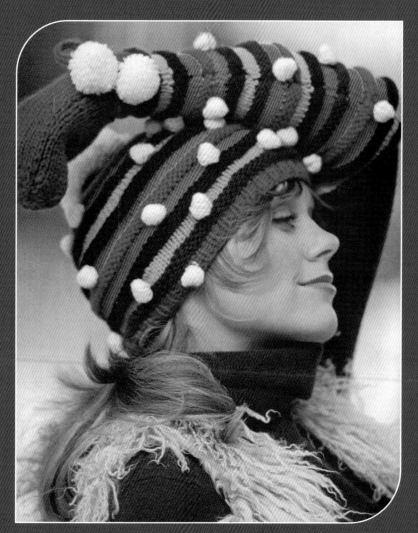

Could it be that this woman has just lost the mother of all spitball fights? Or won the world's smallest snowball fight? Perhaps she's trying to fool everyone into thinking there's a nonstop apocalyptic hailstorm happening. Maybe she has

THE WORST CASE OF
DANDRUFF

IN THE **HISTORY OF THE UNIVERSE**.

Is she a human nonpareil candy? Have mind-controlling spiders used her as an incubator for their pulsating egg sacs? I wish I could say the answer to any of these was yes, but judging from the yak fur vest, I'm going to chalk this one up to poor decision-making skills.

This seems like such a waste of perfectly good hat space, doesn't it? At the very least they could macramé some dreadlocks and attach them to the rim. Or stuff their extra yarn stash in there for sort of a faux Afro. But these women just look so droopy and deflated, like their scalps are just hanging by a thread, ready to slide off and plop to the floor at the slightest provocation. MAKES ME WANT **TO POKE AT THEM**

WITH A STICK

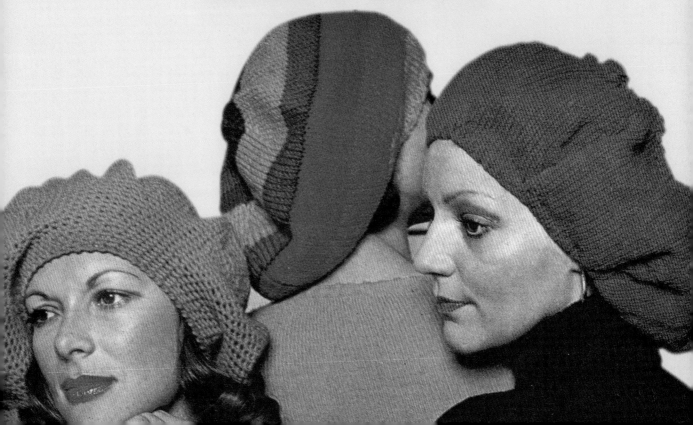

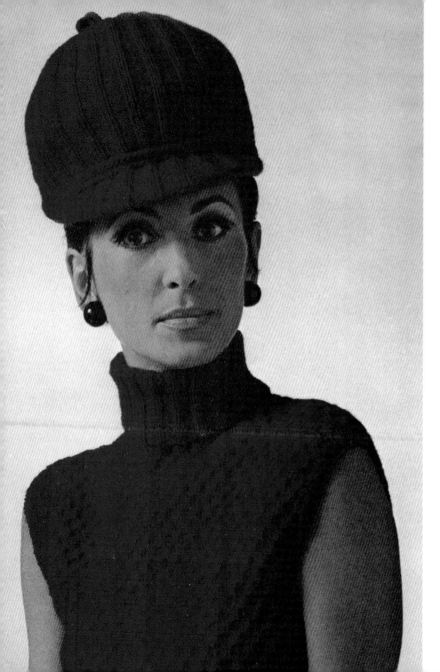

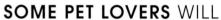

SOME PET LOVERS WILL

stop at
nothing

To get their fur babies onto the airplane with them when vacation time rolls around. Such is the case with Chi Chi the Chihuahua's owner.

Hat or growth?

LET'S EXAMINE IT, SHALL WE?

It does appear to be knitted from thick, warm wool. And yet it seems to be blossoming from the top of her head. Surely if it were a hat it would have been designed to actually fit on her head rather than just perch dubiously on her crown. But how many growths have pom-poms? Its spongy texture offers no clinical proof of its biological or handmade nature. I think what we have here is a hybrid. This amazing new medical discovery is a fleshy blue tubercle that masquerades as quirky yet ineffective headgear! I shall call it Polypus Mike-Nesmithicus.

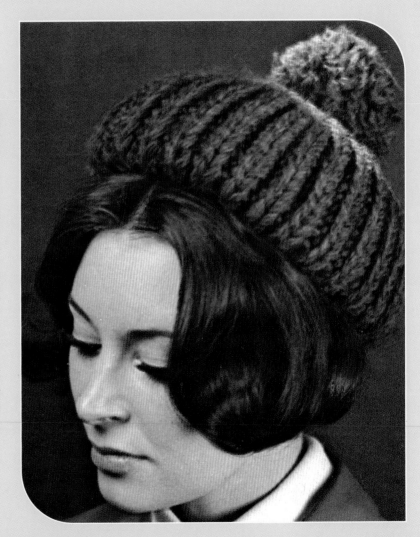

SOME BABIES **ARE COLICKY**
and others are
COWLICKY.

Here's an extreme example of the latter. This Kewpie-esque cherub requires special clothing to accommodate the sharp, horn-like points of hair curling up from his soft, tender head. This adorable bonnet is knitted with sturdy Kevlar yarn to protect people from eye-pokings commonly associated with cuddling him. As he matures, the cowlick horn will drop off, but not until puberty makes him a lethal weapon, requiring his mother to knit all manner of pointy undergarments to keep his schoolmates safe.

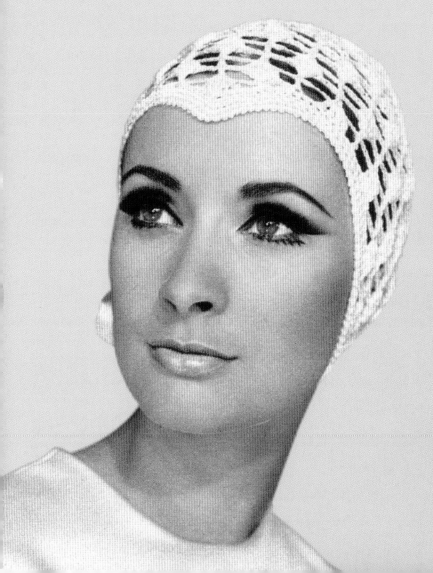

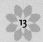

PEOPLE OF EARTH, **DO NOT**

fear us.

We have peaceful and fashionable intentions. We at the Venutian Ladies League have determined that cranial embellishment on your planet is unsatisfactory when compared with intergalactic standards. The VLL has come to share our technology so that your citizens may have a chance. Our hearts, as you call them, ache at the thought that none of your kind has ever been accepted into the Ms. Carbon-Based Lifeform Pageant. We really think you could do it if your heads were properly adorned. And maybe if you took off your glasses. And made yourselves up a little. And got your eyebrows waxed. And didn't slouch so much. Oh, never mind, we'll never win that bet with the Ladies Guild of Pygmalion 3.

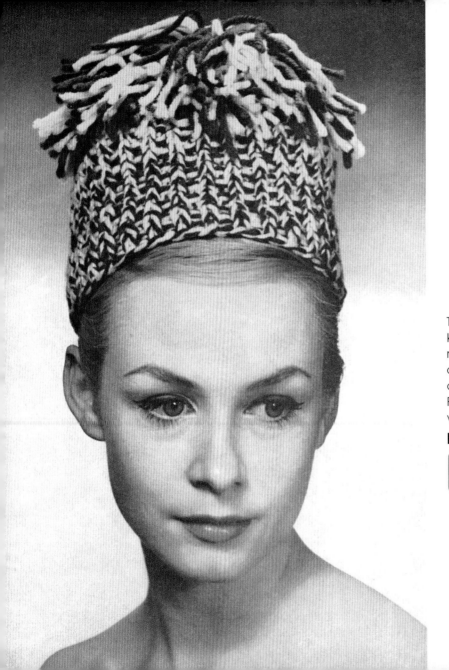

This woman is gorgeous. Like Nicole Kidman gorgeous. And yet this ridiculous fez makes her look like an organ grinder's monkey being crammed through a Play-Doh Fun Factory. If it looks this bad on her, what chance do you think you have?

MARK MY WORDS, IT CAN ONLY

end in tears

Fashionable ladies in the know often
DON A HAT **TO COVER UP A**
BAD HAIR DAY.
But what's a girl to do when she's having
a bad hat day, too?

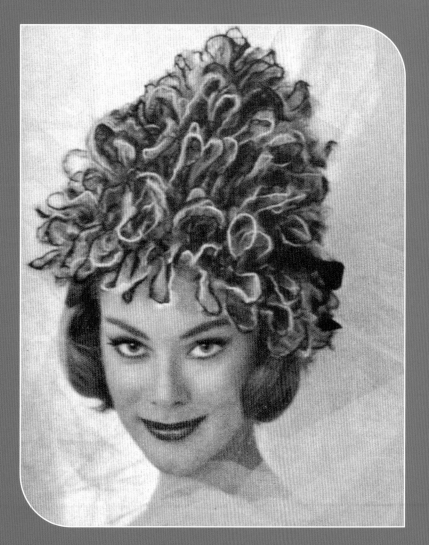

This just in! Two local children have finally been freed from the gaping maw of Pac Man and another un-named suspect. This dramatic photo was taken moments before the rescue. What was it that caused this once-beloved video game character to turn to a life of crime? Some say it was the constant popping of pills as he wandered aimlessly through life. Others speculate it was the ghosts that haunted him no matter where he went. Perhaps his mind finally gave way to hallucinations of various fruits and occasional pretzels that plagued him. He claims he was brainwashed by the Donkey Konganese Liberation Army, but we'll never know for sure. When we contacted Ms. Pac Man, she unleashed a vicious verbal attack on her estranged common-law husband.

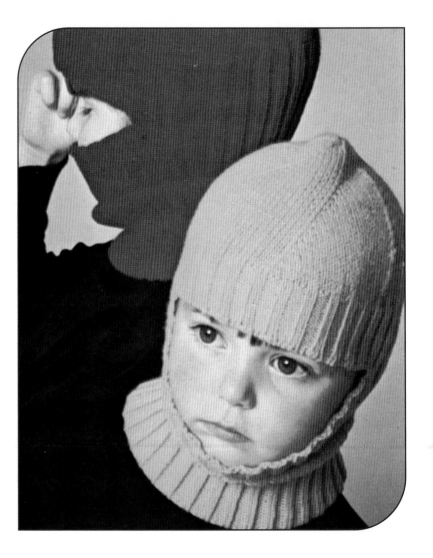

BABY AND JR.
PAC MAN
WERE NOT AVAILABLE FOR COMMENT

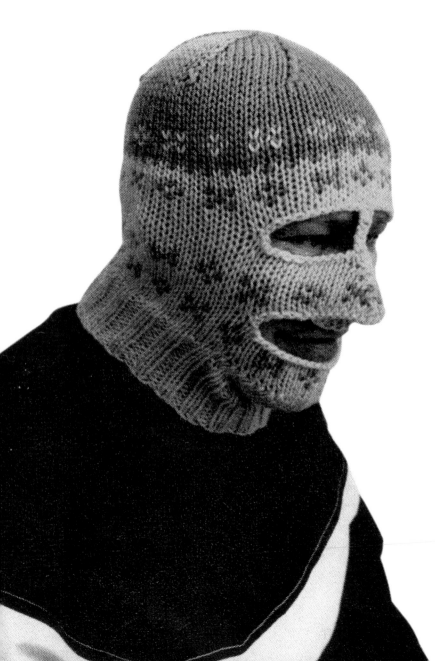

PLEASE EXCUSE ME WHILE I
scream
and scream and scream!

And then evacuate my bowels and collapse into a quivering heap.

There, that's better. No wait, I feel a severe case of the creeping willies mixed with some heebie-jeebies coming on. You don't mind if I sob quietly for a little while, do you?

Oh, how rude of me! Let me introduce you. This is Leatherface's more sadistic cousin, Yarnface.

2. YOU KNIT FOR YOUR MAMA WITH THOSE NEEDLES?

BAD GIRLS, WORSE OUTFITS

Believe it or not, there was once a time in our great nation's history when women flaunted their sexuality by way of hand-crafted fashion. Why rely on clothing manufacturers when you could use your own two hands to make the world stop and ask, "Macramé plant holder or breezy summer top?" These crafty gals used only the best Orlon Acrylic, so their homemade bras didn't burn so much as they melted—but the petroleum-laden fumes smelled like liberation! Once freed from the shackles of society's rules about what constitutes appropriate and comfortable attire, they were able to express themselves with knitting needles, crochet hooks, and only ten feet of yarn.

Luckily, society has moved on to more wholesome pastures, but here's a look back at a time when naked flesh and acrylic yarn played dangerously together. Relax, take off your pants, and stay a while! Here's an erotic pillow for your comfort.

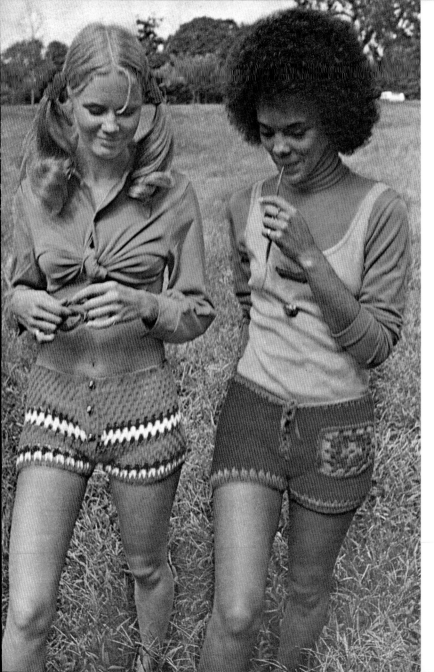

"Color is only one of the vital notes of excitement in these lively fashions!" boasts this pattern's publisher, winner of 1972's Master of the Obvious award.

THEY CALL THEM **"MINI SHORTS."**

I CALL THEM "UNDERWEAR"

—tomato/tomahto, really. Whatever you want to call them, these hot little numbers demand to be made from that camel hair yarn you've been wondering what to do with. They've already got the toes, so you may as well toss the rest of the camel in there.

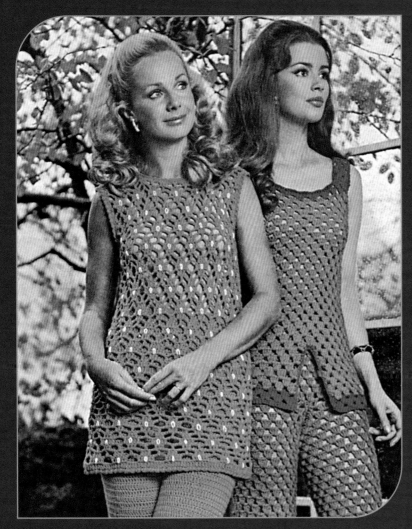

Tired of all that pesky undressing when you want to go streaking? Well, strip no more! Now you can be naked all day and wear shoes to match with this fabulous Peek-a-Boob pantsuit—

NOW WITH 25 PERCENT MORE NUDITY!

YOU'LL BE THE ENVY OF ALL **THE GIRLS ON THE CORNER**

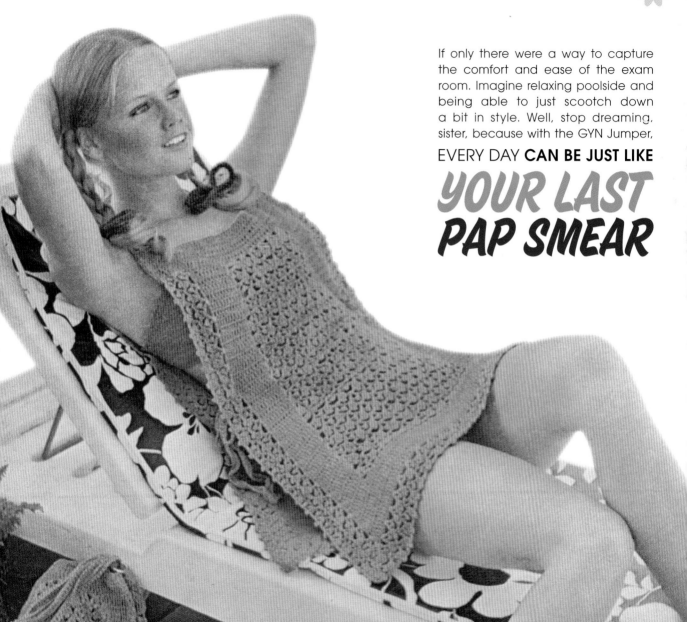

If only there were a way to capture the comfort and ease of the exam room. Imagine relaxing poolside and being able to just scotch down a bit in style. Well, stop dreaming, sister, because with the GYN Jumper,

EVERY DAY CAN BE JUST LIKE
YOUR LAST PAP SMEAR

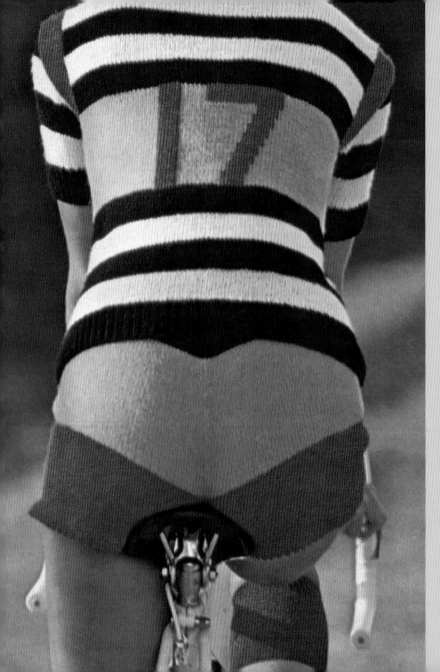

EVER WISH **YOU COULD HAVE**
A WEDGIE

consisting of an entire skein of your favorite yarn? Do you want to learn how to felt wool with sweat while wearing it? Then have I got a project for you! This sensible bicycling outfit combines all the breathability of a plastic sandwich bag with the comfort of a bear trap. Add to that the unmatched creeping properties of knitted shorts, and you'll be tearing up the trails in no time! Amazingly, these shorts came down to her knees when she started the Tour de France earlier in the day. She's going to need a crowbar to get undressed.

Well, wait a minute. This lovely sweater is the height of modesty. Long sleeves, high neckline—nothing revealing about this. Why, this demure young lady could be

THE HEAD OF THE PTA

OH MY!

I didn't realize that PTA stood for Pants Tossed Aside! My guess is that she'll find any excuse to put her feet on the furniture in this getup. I defy anyone to maintain eye contact with this woman for more than 3 seconds. Go ahead. Try it. You can't! And she knows it.

KNIT YOUR OWN THING THIS SPRING.

A GUARANTEED LOOK.

. . . errrrr . . . and if your "thing" happens to be diapers—all the better! There just aren't enough crocheted unhappy-face pillows in the world to express my feelings

FOR OUR **PATRON SAINT OF** PERVERSE YARN FETISH.

I'm not even sure what the appropriate venue for this outfit would be. Does she need to call her friends ahead of time to tell them not to wear their brown leotard with diaper-skort and matching head wrap when they head to the miniature golf course? Well, at least the makers of this new and improved acrylic yarn (now with polyester!) are offering a guarantee they can stand behind. People will definitely be looking. Maybe they should have upped the ante a bit and offered a guaranteed open-mouthed gape!

Just look at the way the fox in the yellow tank top is looking at Mr. Smooth. It's as though she's been stranded in the desert, surrounded by cartoon skulls, hallucinating about a watery oasis, and

HE'S A **SIZZLING BARBECUED**
CHICKEN LEG!

And the fox in stripes is laying claim to everything that giant belt buckle has to offer and then some. Somewhere, right now, there's a bass player plucking out porno chords and searching for a scene just like this one. You just know that the next page of this pattern book originally featured Mr. Smooth modeling a crocheted banana hammock for the lovely foxes.

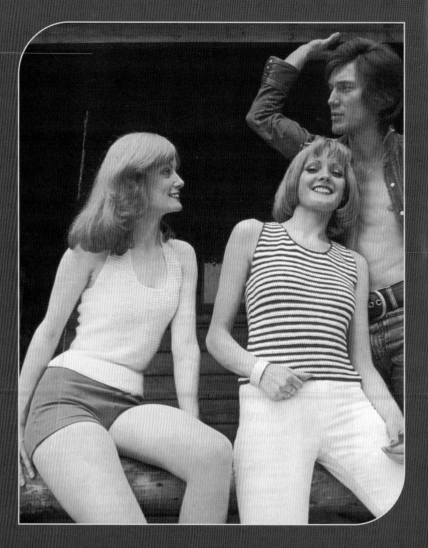

I can understand a little nipple slippage on the red carpet when you're a B-list celeb stuffed into a dress that's four sizes too small. I can even understand it when you're wearing a tube top and the elasticity gives way to humidity and possibly a trampoline. But to intentionally spend hours knitting a sweater that you know is going to give the world a bird's eye view of your girls, well, that's just irresponsible. Could that be why she's standing in front of the

INTERNATIONAL SYMBOL FOR

"HELL NO!"?

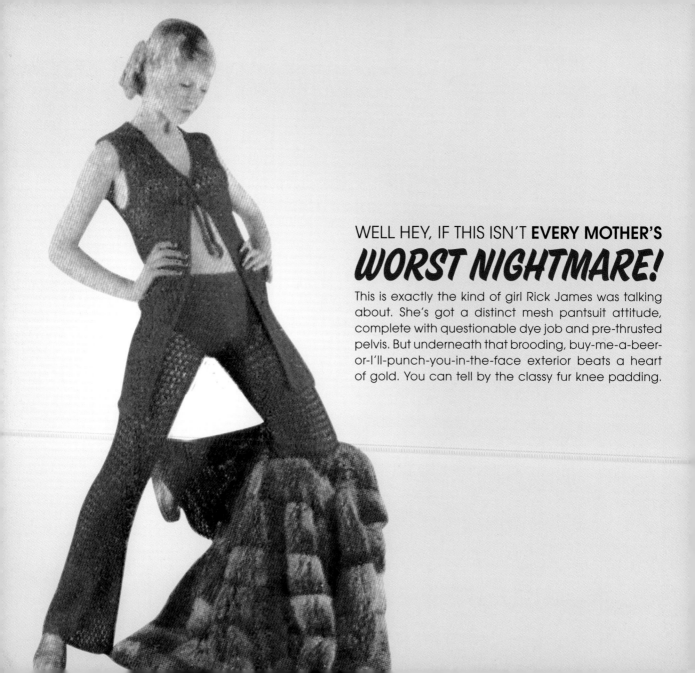

WELL HEY, IF THIS ISN'T **EVERY MOTHER'S**

WORST NIGHTMARE!

This is exactly the kind of girl Rick James was talking about. She's got a distinct mesh pantsuit attitude, complete with questionable dye job and pre-thrusted pelvis. But underneath that brooding, buy-me-a-beer-or-I'll-punch-you-in-the-face exterior beats a heart of gold. You can tell by the classy fur knee padding.

Whatever became of these women of easy virtue and cheap fiber? Did they overcome their wanton ways or succumb to the acrylic heartache for which they were bound? I can tell you in two simple words:

YARN SORES.

DON'T LET IT HAPPEN TO YOU

✿ 3. YOUR WORST KNITMARE

A HORROR SHOW OF FAUX FUR MONSTROSITIES

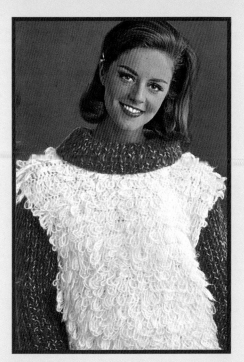

Strange creatures are all around us. For many, these unspeakable demons haunt us in our very own homes. Their musty, matted pelages are ripe with the stench of old shoes from the back of the closet or are thickly coated in dust bunnies and cracker crumbs from under the bed. Unless you're willing to take on evil in its purest form, it's best to not even think about them. But if you're brave enough to face the most vile of this Earth's offerings, you will learn the horrible truth. Bear in mind that once you know, you cannot unknow. Once you have seen, you cannot unsee. Prepare for this blood-curdling look at your worst knitmare: yarn fashioned to suggest the presence of fur! But fear not, these long-forgotten acrylic beasts are perfectly harmless when thoroughly mocked, so mock we shall.

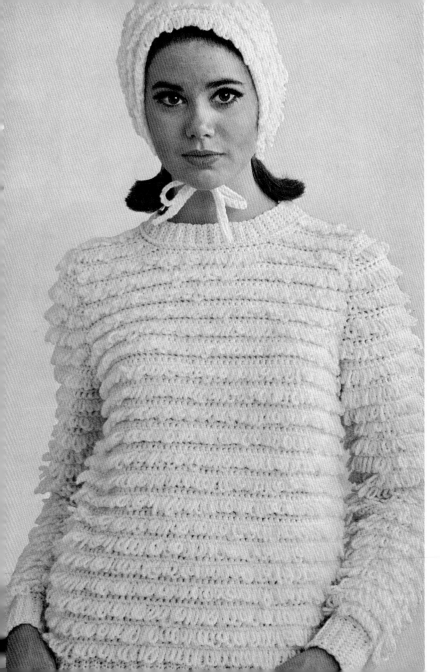

There's something unnerving, creepy even, about the innocence of this woman-child and her sickeningly sweet outfit. Those big doe eyes, the fluffy white sweater, the matching bonnet—something just isn't right. It's as though Mary took her little

LAMB

WHOSE FLEECE WAS WHITE AS SNOW then chopped him up for a sweater set, the hat tied in a bow.

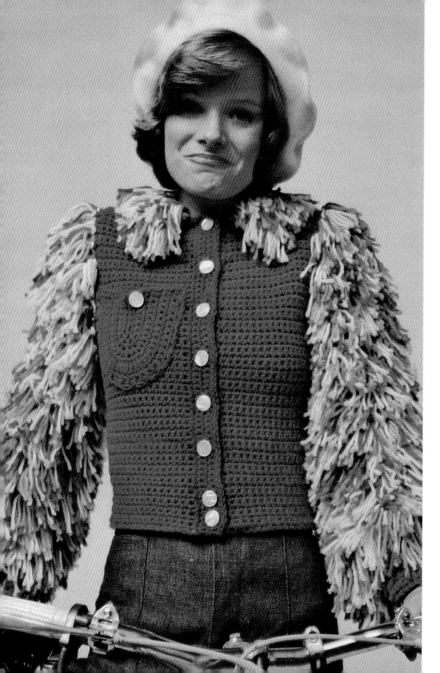

It's interesting to see what happens when you combine a fashion shoot and a hostage situation, don't you think? Clearly she's modeling this jacket against her will, and it's simply part of a process meant to speed up the Stockholm Syndrome. The strange U-shaped pocket will cloud her thoughts. The crooked row of blinding buttons will make her question everything she's ever believed. **ULTIMATELY, THE ACRYLIC SHAG**

WILL BREAK HER SPIRIT,

leaving her an empty shell of the woman she once was. By day's end, she'll be convinced that this is high fashion, and soon she won't be able to leave the house without having her limbs covered in a tangled mess of cheap yarn.

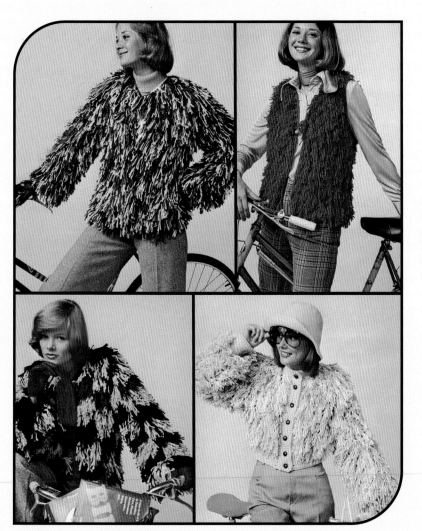

And with the brainwashing complete, she and her shaggy band of misfits will bicycle around the countryside **LOOKING** FOR SCENERY

TO DESPOIL

It's tragic, but there's no saving her. Once the Abominable Yarn Beast has your head firmly clenched in its argyle jaws, it's best not to struggle. Accept the furry hands of fate and realize that once you've made a fashion faux pas this bad, there's no outliving it. You will now and forever be known as

MS. SASQUATCH, 1974

This is an affront to fur-bearing creatures everywhere. At this very moment, hordes of animals are ready to step out of their pelts and offer them up to anyone who actually made one of these . . . vests . . . that's a vest, right? Or . . . hold on a minute, is this another case of mistaken identity? Keep your skin on, little critters.

FALSE ALARM.

SHE'S WEARING **THE BATHROOM RUG.**

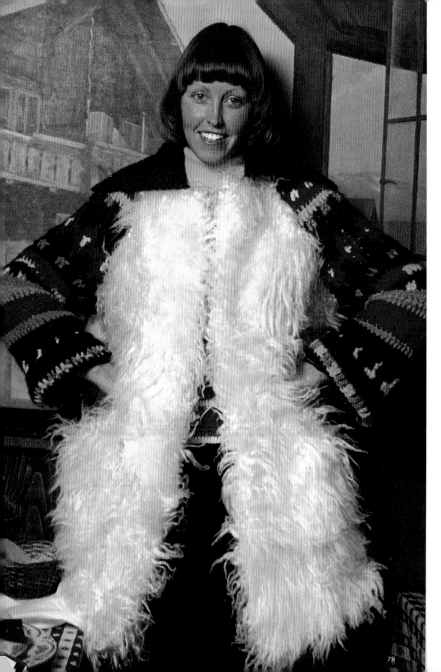

Why assault just one sense at a time when you can take a whack at all five at once? By combining the durability and bouquet of Yeti fur with a palette of wholly unappealing colors, this "Coat of Many Wrongs" gets it right. The migraine-inducing beauty of the sleeves will leave onlookers nauseated and dizzy—with envy. The squeals of frightened children in your wake will be your new calling card.

THE ALLURING SCENT OF
YETI MUSK

will envelop you in a swirling cloud of room-clearing fumes. The tactile sensation of matted fur and scratchy yarn will send shivers up your admirers' spines, in some cases even causing vertebrae to fuse. And as far as taste goes, it's bad. Very bad.

Oh Lord, this is the couple you always hope to avoid at a party. Could there possibly be two more annoying people on the planet? Their careful choice of outerwear serves as a crystal-clear warning that they consider themselves to be a "fun and adventurous" couple. There's no getting around it—they'll be asking you to join them in the hot tub before you can say "no more schnapps for me, thanks." Not so coincidentally, this will also be the exact moment you discover that their choice of underwear is just as bizarre as their matching set of

MORON PONCHOS.

You haven't seen anything until you've seen matching knitted G-strings, complete with fake fur and strategically placed pom-poms.

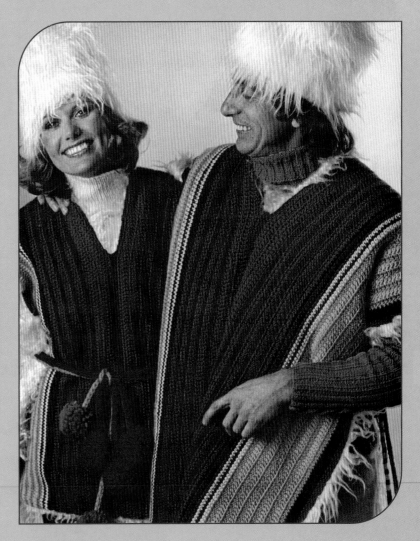

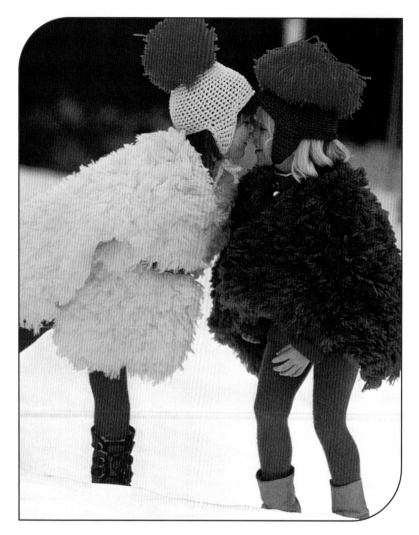

Someone please explain what I'm looking at here. I could be wrong—and let's all hope that I am—but are these the progeny of some twisted man/puppet love thing? Are there scientists somewhere serving romantic candle-lit dinners to women and their dust mops, just to see what happens? Is this some sort of birth defect associated with using too much crappy yarn and not enough good sense? I knew something like this would happen if people didn't wise up and quit abusing acrylics! Oh, when will people learn? WON'T SOMEONE **THINK OF THE**

CHILDREN?!

WELCOME TO POLYESTERYEAR

AN AGE OF UNFORGIVABLE SYNTHETICS

Once upon a time, an entire generation of people decided to embrace the absurd and pretend that nothing strange was going on. This Zen-like act of acceptance may have been good for the soul, but it was murder on the eyes. Colors didn't just clash, they engaged in epic battle. A sudden influx of incomprehensible patterns and textures only served to add fuel to the fire. Suddenly everything humankind had learned about style was cast aside to make way for a new regime of ridiculousness. The knitters just had to get in on it. Their needles clicked furiously as they created styles that fed a nation yearning for the dark side of fashion. During its heyday, this age of unforgivable synthetics left no closet untouched, no citizen unsullied, and no family photo above reproach.

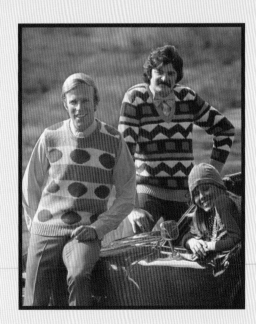

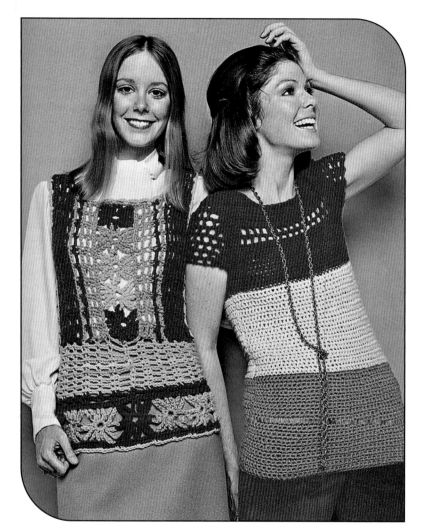

WHY AM I **SUDDENLY IN THE**

MOOD FOR
SPUMONI

and grandma's ribbon candy?

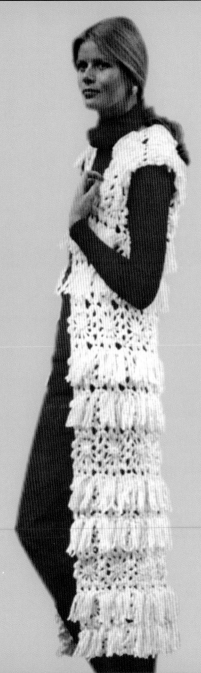

Put your friendships to the test with this stunning ankle-length vest! If they're embarrassed to be seen with you, they're smart, self-respecting people. Stick with them and learn a thing or two. If they go on and on about your fantastic sense of style, drop them like the piping-hot potatoes they are. And for the love of all that is holy, once you've sorted that out, get rid of that

RIDICULOUS VEST!

When you find yourself knitting outfits to match the lamps in your home, it's time to step away from the needles. Find a new hobby, check yourself in to a sanitarium, whatever you must do to keep yourself from making a dress that looks

EXACTLY LIKE THE REFRIGERATOR

Score a bogie to the power of ten with this pair of clingy sweaters! Ready to say goodbye to all that unwanted chest hair and look fab doing it? Now you can, with our patented manscaping zipper technology, modeled here in blue. Or accentuate every sensual curve of your love handles and Sansabelt slacks with our kicky orange number. And remember, never, *ever* underestimate **THE POWER** OF A FULL-FRONTAL

WEDGIE,

so always keep your trousers snug and your boys in place. Take a fashion mulligan, fellas. You've earned it!

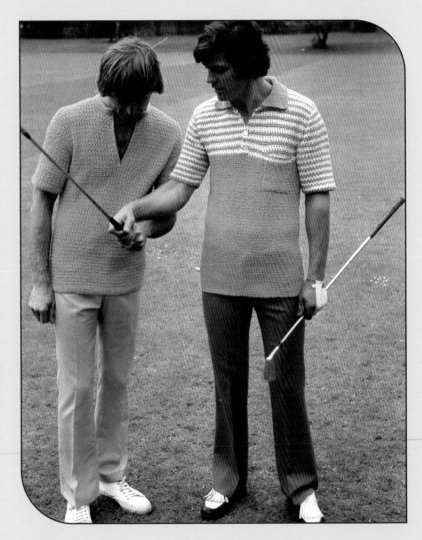

This is some vest—just look at the way it complements the ascot without overshadowing the clothing underneath. But just how long is this thing? We'll never know for sure, but I like to think it goes all the way down

TO HIS ZIP-UP NAUGAHYDE

ANKLE BOOTS.

Or maybe the kid is scanning the horizon for the end of the mile-long netted tubing with her field glasses. Whatever the case may be, I can only hope that anyone who ever intended to make this for their special someone just broke up with him instead. That's what was going to happen when he tried it on anyway, right?

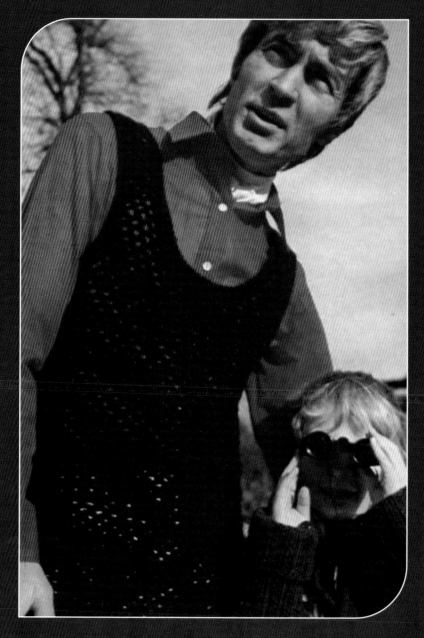

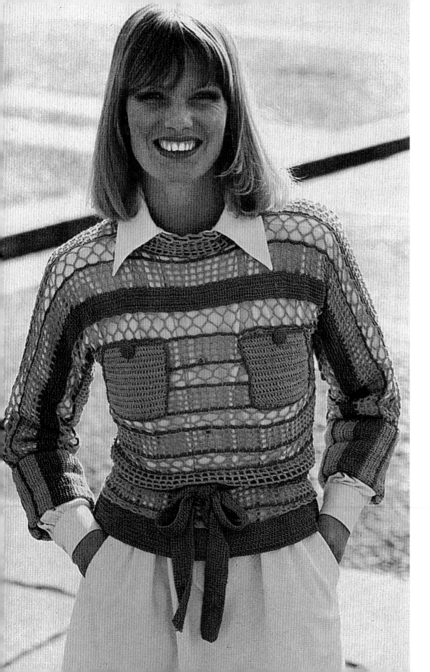

LOOKING FOR THE CONVENIENCE OF

BREAST
POCKETS

without committing to an entire sweater? Well, here's the perfect solution! A fishing net, some construction-paper envelopes, and a couple of pushpins would also do the trick.

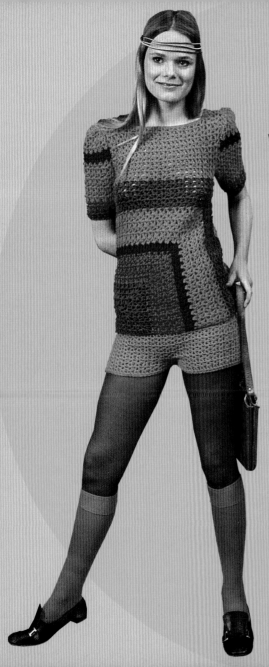

WITH THE ADDITION OF **LAYERED**

HOSIERY,

solid brass fittings, and a shapeless sweater that could make even the perkiest breasts look like low-hanging fruit, the term "hot pants" seems a bit excessive. Perhaps "mildly tepid pants" would be more apt. One more pair of socks or another piece of cranial hardware and we'd have a pair of "Antarctic pants" on our hands.

When every one of their conversations inevitably turned to her fondness for

LEDERHOSEN

AND THE **MEN WHO WEAR THEM,**

he should have suspected something. But how could he ever have guessed it would go this far? This used to be his favorite white sweater. He's starting to think that telling her to "get a damned hobby" was not such a great idea after all. Let's hope he's learned his lesson.

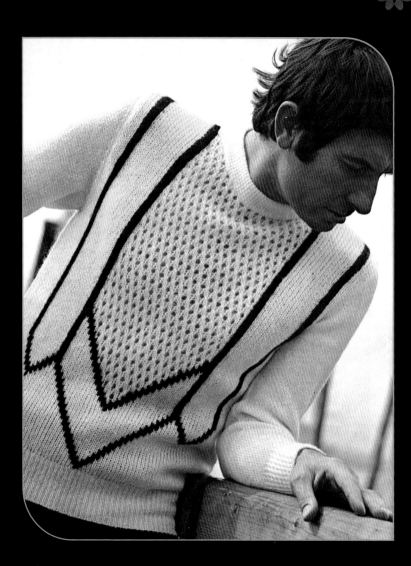

5. DRESS FOR SUCK-CESS

FROCKS THAT SHOCK

Fashion can be a fickle mistress. You never know whether she's going to be kind or give you a karate chop to the neck. Sometimes you manage to pull off a "Fashion Do" and can walk tall knowing that not only do you look better than everyone else, you *are* better than everyone else. Other times you stumble through the day in a "Fashion Don't," convinced you're going to end up in the back pages of a fashion magazine with your eyes covered with a black square. It happens.

This is the ebb and flow of life, a natural cycle that keeps Earth on its axis. And then there's the "Fashion Oh-No-You-Didn't." This is a siren call to killer asteroids that threaten to send Earth careening wildly out of orbit, flinging everything into the great black void of space. As a public service, we have put together a visual guide to some of the world's most dangerous dresses. Learn them. Know them. Should they fall into the wrong hands, the results could be disastrous.

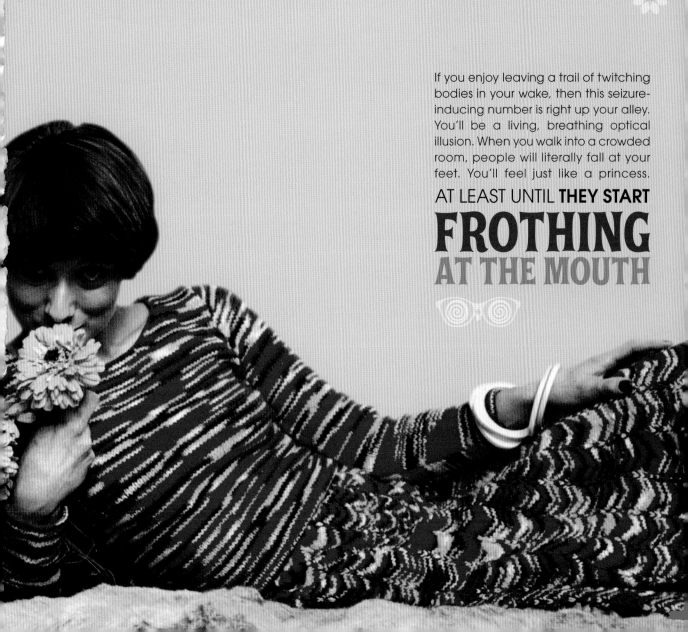

If you enjoy leaving a trail of twitching bodies in your wake, then this seizure-inducing number is right up your alley. You'll be a living, breathing optical illusion. When you walk into a crowded room, people will literally fall at your feet. You'll feel just like a princess. AT LEAST UNTIL **THEY START**

FROTHING
AT THE MOUTH

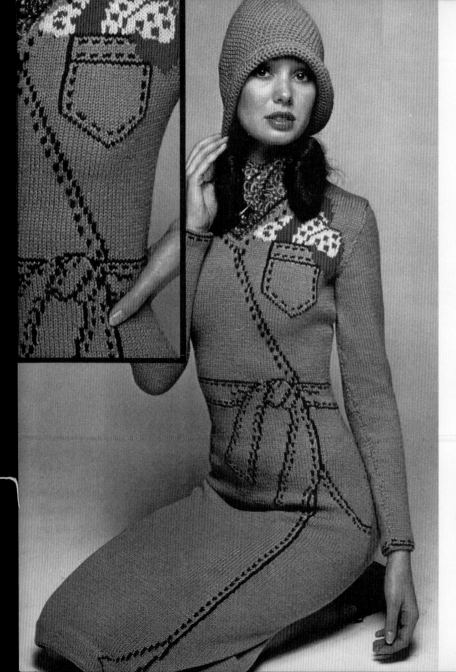

Back in the Wraparound Dress Famine of nineteen hundred and seventy-two, folks had to get creative to meet their wraparound dress needs. Here's an ingenious replica complete with an imitation belt, artificial pocket, and a simulated silk scarf. The designer has even faithfully recreated the illusion of the dress blowing open. Yesiree,

IT WAS **THE PERSEVERANCE OF**

THE HUMAN
SPIRIT

that helped us through that difficult year.

STEP 1:
Gather all of the world's yarn supply into one place.

STEP 2:
KNIT AND KNIT AND KNIT UNTIL

YOUR FINGERS
BLEED.

STEP 3:
Knit a little more.

STEP 4:
Poke holes for head and hands.

STEP 5:
Climb into the shapeless sack you've just created.

STEP 6:
Congratulate yourself on your miraculous transformation into an amorphous blob who knocks over everything she tries to pick up with her formless appendages.

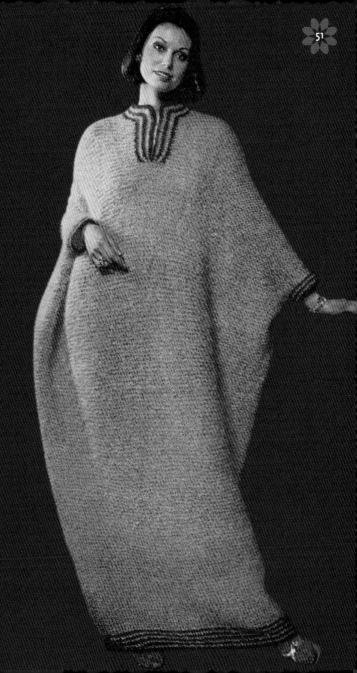

I have no idea what this dress is made of, but this lady is leaving strange marks on the furniture, so I think it might be a cheddar/sandpaper blend. And if I'm not mistaken, the frilly trim is made from aerosol cheese-in-a-can painstakingly extruded and applied by hand. Such finery, such attention to detail,

SUCH A STRANGE
ODOR...

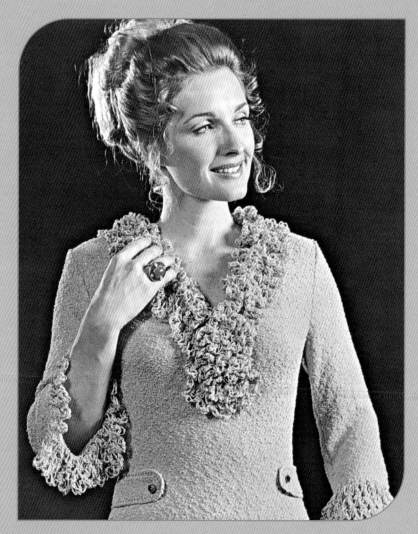

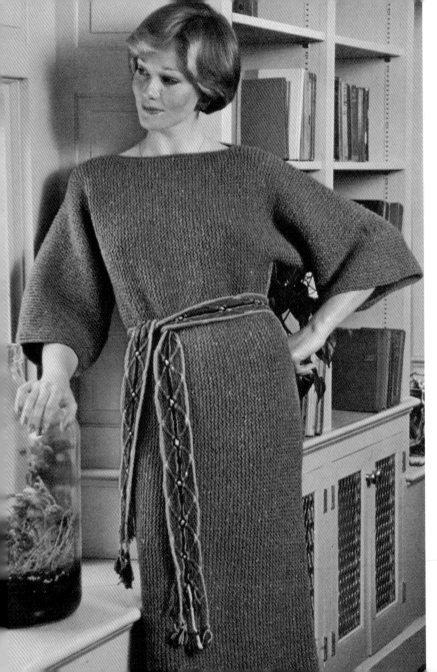

Let's hope that since becoming a monk,
SHE HAS TAKEN **A VOW TO**

NEVER
KNIT AGAIN

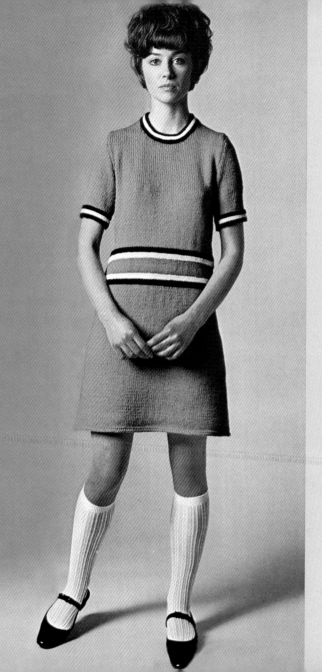

This dress wouldn't be half bad if Little Orphan Granny here wasn't a grown woman. Honestly, unless she's a stripper with a gimmick, this whole outfit does not compute. Do the math! Shapeless schoolgirl minidress + white knee highs + Mary Janes + 35-year-old =

PERVERTED

YOUTHFUL EXUBERANCE

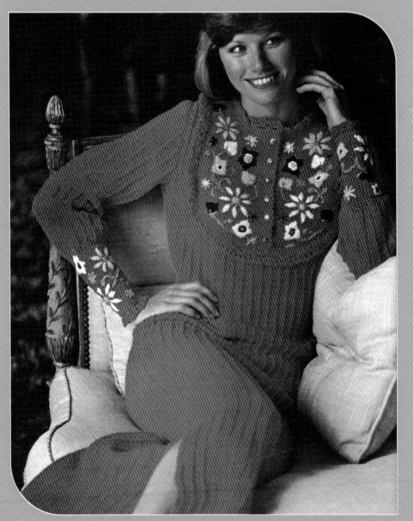

The world is your slumber party in this nightgown-inspired beauty. Round and round the club she goes—

WHERE SHE'LL WAKE UP,

NOBODY
KNOWS...

Do you ever get the feeling that the fashion industry is making fun of us? That they think we're a bunch of suckers who are mere slaves to their bizarre whims? That they assume

WHEN THEY SAY "CROCHET"

WE SAY "HOW UGLY?"

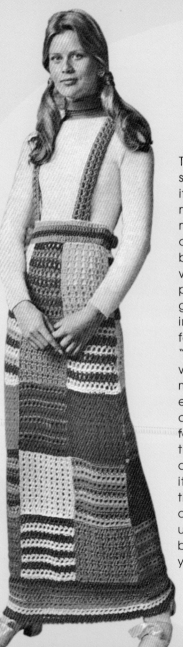

This pattern is from the '70s, but I've seen the signs that it could be rearing its hideous head again soon. Trust me when I tell you that at this very moment, this little gem is churning away in the giant retro machine, biding its time until it thinks we're weak. And then, when we least expect it, some malnourished starlet is going to stagger up a red carpet in this very abomination. It's time for us all to stand together and say, "No. Not this time." We believed you when you told us leg warmers would make us look fit. We eagerly belted every sweater, vest, and shirt we could get our hands on. We fell for the bellbottoms. Twice. But this time, we will resist. We renounce the candy-colored patchwork skirt and its vaguely matching suspenders that are more likely to stretch and droop than they are to help hold up this wretched thing. We cast you back to the fiery pits from whence you came!

☸ 6. GLAMMA!

ACRYLIC COUTURE FOR KLASSY KNITTERS

Is looking like a million bucks still a good thing if you look like a million bucks-worth of crappy yarn? Is a floor-length gown still formal if it's indiscernible from the afghan you got from demented old Aunt Trudy? Can you dress with champagne style on a beer budget? Yes, yes, and yes! Without this special brand of questionable couture, every stuffy party at every yacht club in the world would be mind-numbingly boring. Forget small talk with the van den Berghs. Discussion about new tax laws with the Dempseys can wait. And unless old man Johnson is going to offer you his place in Aspen for the weekend, keep walking. People in "sophisticated" hand knits are a special bunch, so don't deny yourself their company. Come on, let's mingle.

Now here's a dame who knows how to accessorize. See that ring on her finger? It's got four carats' worth of diamonds on it. See those giant pearl earrings? She spent an untold fortune having oysters genetically mutated to produce them. See that sweater festooned with dangly bits?

SHE HAS AN ENTIRE STAFF OF

MONKEYS

that tirelessly crochet pasties for her botched boob job. They add a certain something to the festivities, no?

WOMEN'S LIB

ain't got nuthin' on our little house-wife here. She just hates to leave the kitchen. So when it came time for hubby's company Christmas party, she knit herself a formal evening apron. Now she can enjoy a night out and still show solidarity with the appliances. "She's a treasure, that one," chuckles her husband. If the dishwasher repairman were here, he'd agree. Wink wink.

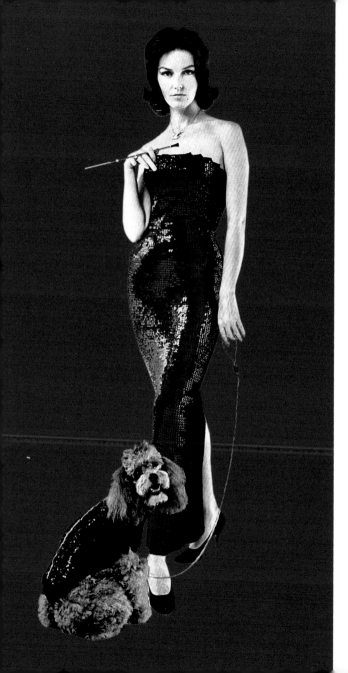

ARE THESE A COUPLE OF **CLASSY BITCHES**

OR WHAT?

Who would be bold enough to put giant shoulder pads in a sleeveless top, you ask? Who could wear a miniature poodle's gold lamé collar as a belt? Who could make Joan Crawford put down the wire hangers and take notice?

A DOMINATRIX

CIRCA 1947, **THAT'S WHO.**

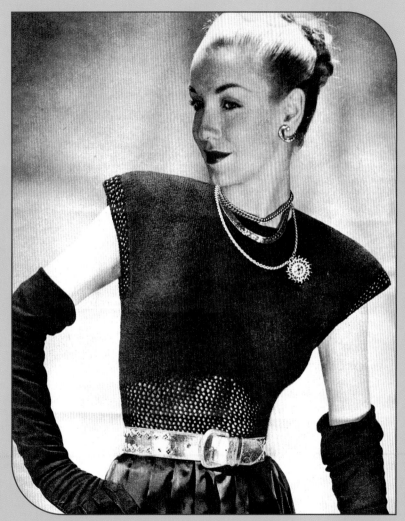

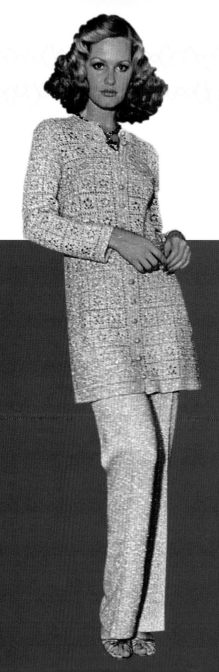

Don't let the prying eyes of Big Brother keep you from having a good time. Protect yourself from harmful government spy rays and look ravishing with this sparkling foil pantsuit.

OPTIONAL FOIL HAT WILL BLOCK ALL

MIND
PROBES

and add a jaunty touch to this enchanting, slightly noisy, ensemble. Plus, it's perfect for tucking away leftovers from the buffet! She's got to have some bacon-wrapped scallops in there somewhere.

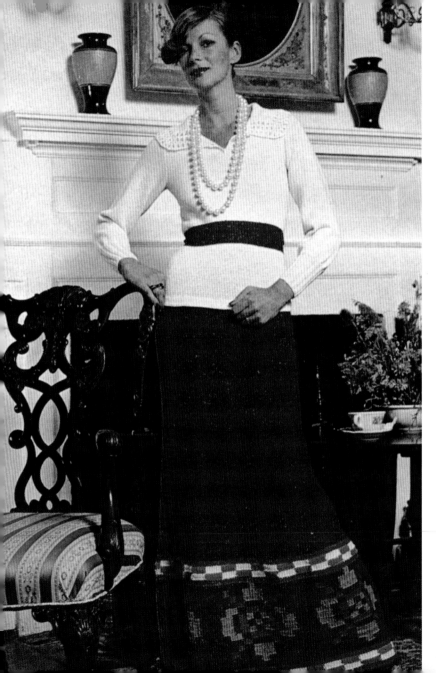

It looks like this devious international

RUG THIEF

is going to make another score, this time with a very valuable early Native American piece.

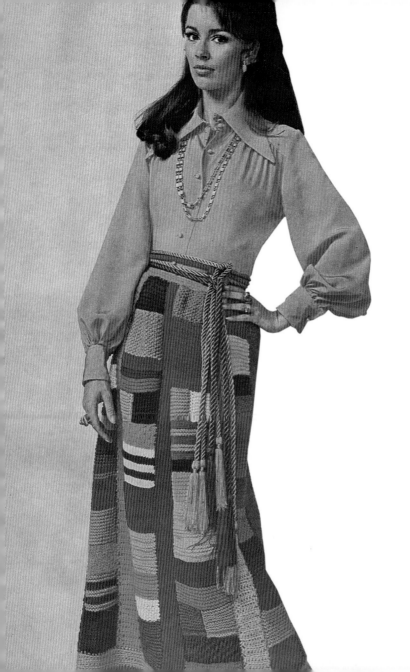

SHARPEN YOUR COLLARS, GRAB
THE BEDSPREAD,

and gather up all the curtain tie-backs—it's time for a night out on the town! Honestly, at this point, it's just better to cancel your plans. Pretend you have relatives in town or that you've got food poisoning. Or try telling the truth. Tell them you've gone temporarily insane and you almost wore bedding to the dinner party. They'll understand. They might even thank you.

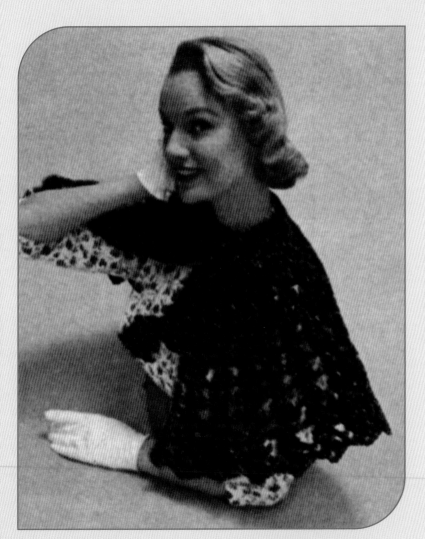

Ms. Witherbottom gets around just fine, and with all the money she saves on pumps and crinolines, she can BUY **ENOUGH YARN** FOR ALL THE

HALF-SHAWLS

she'll ever need. It's all worked out really well for her.

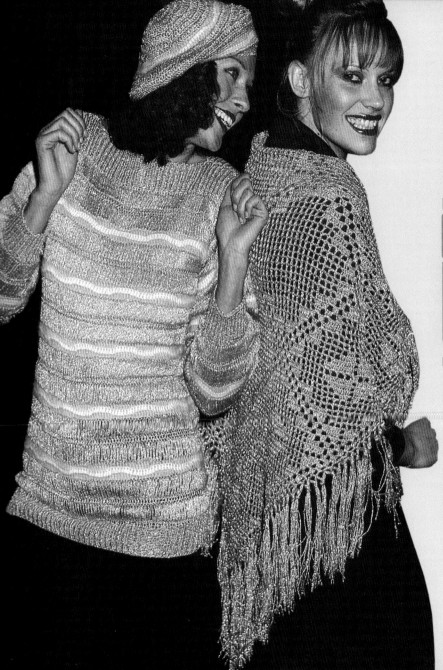

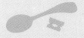

Oh yeeeeeaah! We've found the life of the party, and it's all coked up, just like we thought it would be. These two just prove the theory that if you

FIND THE **WOMEN ENROBED IN**

GLITTERING YARN

at any party and can match them drink for drink, you're in for quite a night. The world is their Studio 54. Run out of blue eye shadow or Charlie cologne? No problem, they've got plenty to go around. And you'd better believe they're wearing their boogie shoes. Just save enough money for bail at the end of the night, because sister, you're gonna need it.

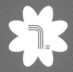

EMASCULATION NATION

MENSWEAR THAT MAKES MEN SWEAR

Feast your eyes on this stunning collection of atrocities for the unlucky men in our lives. Are they handcrafted out of love or masterminded to drain a man's essence? Either way, if you can get him to put it on you'll know that his soul is yours for the crushing. For maximum effect, show this to the man you love, wield your knitting needles and crochet hooks menacingly, then ask him to do your bidding. Repeat as necessary.

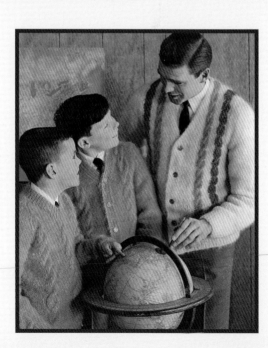

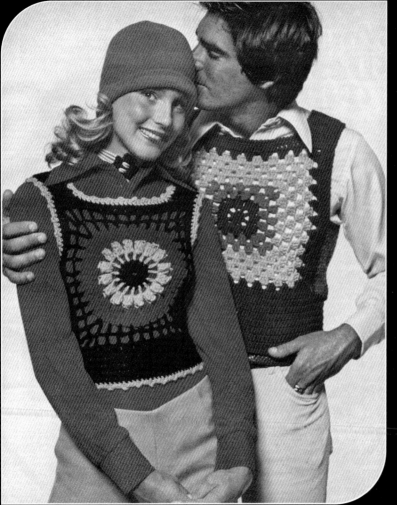

SOME SITUATIONS **DEMAND**

EXTREME
ACTION!

This man has taken Shakespearean steps to exact a swift revenge for the misdeeds of the granny-square crocheting she-devil by his side. While it may look like he's bestowing a sweet kiss upon his lover, in reality, he has coated his lips with a hat-penetrating poison that will render her unable to hold a crochet hook for the rest of her

IF ONLY THIS SWEATER WERE

LOADED.

A quick, clean shot to the heart is the
only way out of this disaster.

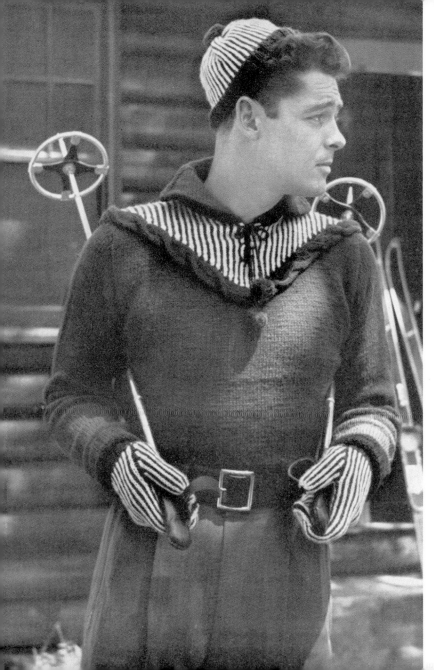

I'm not even sure I understand this outfit. Stripes and cables and tassels, a yoke and collar, all topped off with matching mittens and a precariously placed beanie that will fly off his head at the very thought of shooshing down a mountain. It looks more like a '50s futuristic outer-space uniform reconfigured for slope-bound humans.

DANGER
WILL ROBINSON:

DO NOT ACCEPT THIS OFFERING!

SPEAKING OF **OUTER SPACE**—

YIKES!

This is from a Red Heart pamphlet from 1941 called "Knit for Defense," and it features lots of patterns you can knit for soldiers in World War II. Apparently the idea was to make the Germans think they were battling Venutians, causing them to flee in terror.

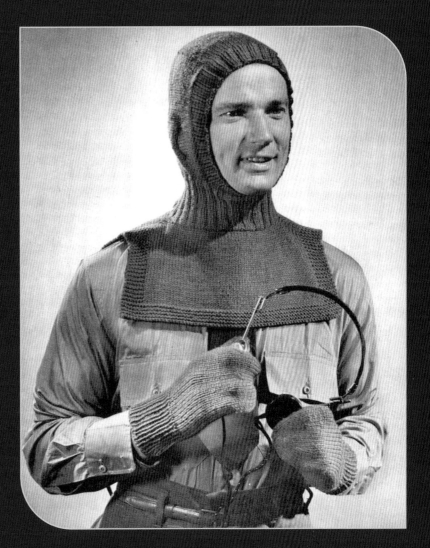

While perusing many vintage pattern books, I uncovered a diabolical plot. I'm not exactly sure of the intended outcome, but frankly, the men do not fare well. I suspect that might actually be the intended outcome. It seems that if it's good for the gander, what the heck—knit one up for the goose! Both the men's and ladies' versions are heinous, but the fellas always seem to come out with the fuzzy end of this bitter lollipop.

CONFUSE
YOUR NEIGHBORS,
UPSET YOUR FRIENDS, AND TO HECK WITH THOSE GENDER ROLES.

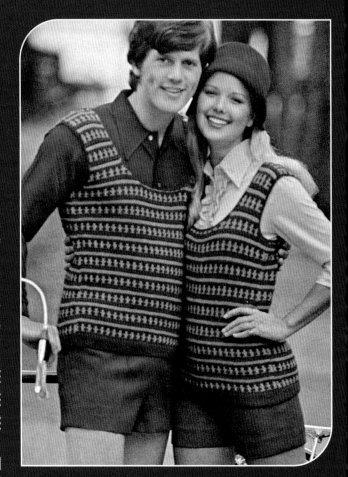

Blur that line between fashion and folly—I'm sure he's done something to deserve it! Toss in a pair of polyester crotch-restricting short-shorts and the kids will be asking, "Why doesn't Daddy come home anymore?" in no time!

TOM

DICK

HARRY

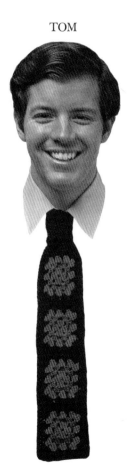

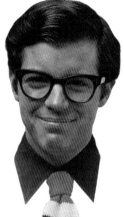
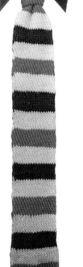

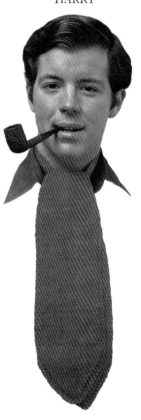

Huh, that's

They all look like **Dicks** to me.

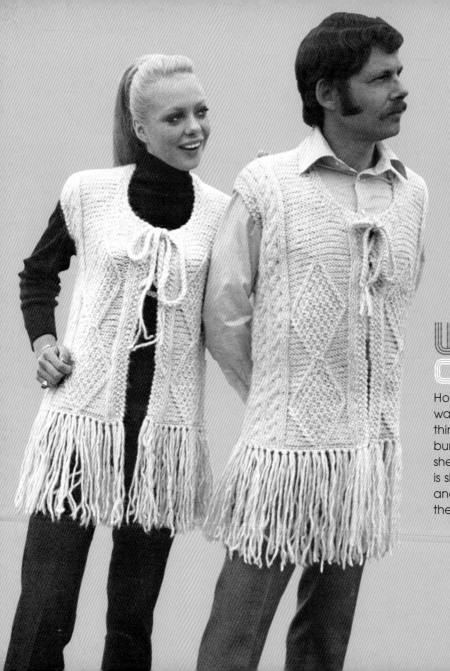

WARM VEST,
COLD SHOULDER.

How could it have gone any other way? She seems to be trying to smooth things over with a playful pinch on the bum, but he's not having it. This time she's gone too far. Looks like someone is sleeping in the rumpus room tonight, and if there's a matching afghan in there, it's not going to be him.

Let's see, we'll use gray yarn . . .
aaaaaaaaand take off the fringe . . .
hmmmm . . . make it a little longer . . .

NOPE—STILL LOOKS LIKE A
COMPLETE AND UTTER
GOOFBALL

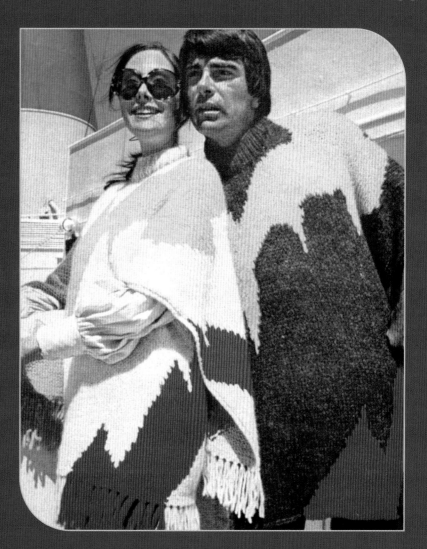

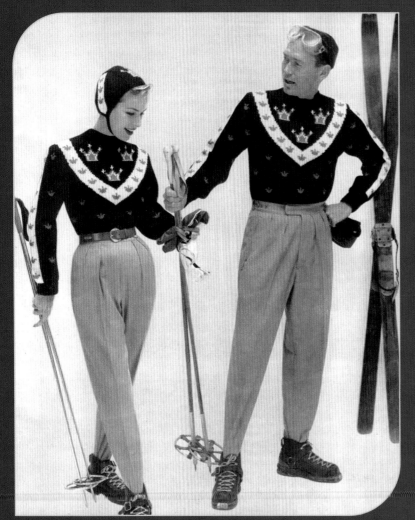

Here's a set that seeks to answer the age-old question, "Just who in the hell does she think she is?" Her sweater is fit for a queen, and so is his. Or at the very least an extremely happy king. And by the looks of it, he is

MOST DEFINITELY **NOT** A HAPPY

KING!

This couple might actually be from a reality-based pattern book—I don't think they're models at all. Opposite, he appears to be giving the missus a hard time about her "crowning achievement," and here he is at home yelling at everyone to "Shut the hell up, I'm on the phone!" I suppose he's trying to call someone to ask just why he has to wear the bottom of his sweater flipped up. He doesn't realize that he's the proud owner of an

ARAN
CRUMB CATCHER,
STATE-OF-THE-ART STUFF **IN 1957**

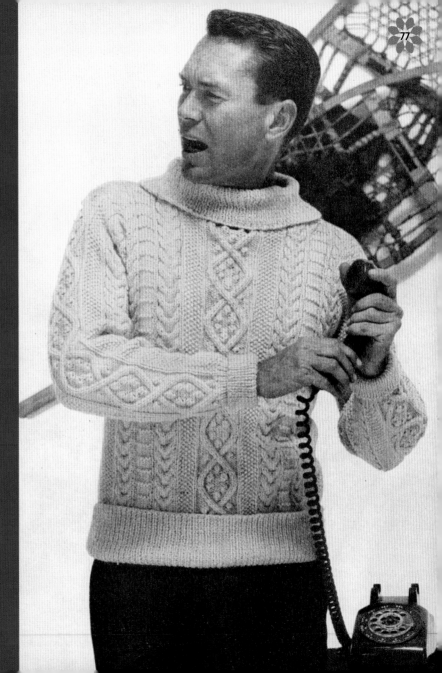

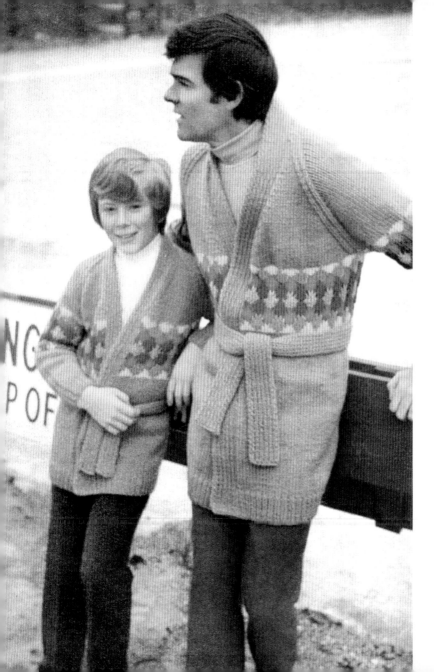

Why wait until he's a full-grown man to start humiliating him? Smart moms can mortify two birds with one pattern! With any luck, Junior will bypass puberty altogether and start collecting Precious Moments figurines right away—just like his old man. (Note that Dad is leaning on the railing with all his weight. Also note that the railing has a sign that says "Danger—Keep Off" in giant red letters.)

HIS SILENT SCREAM IS DEAFENING

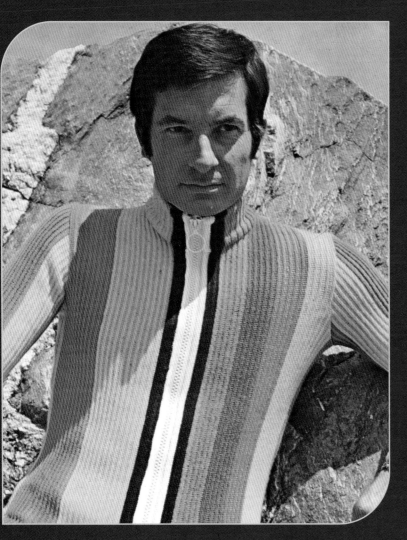

And finally, some help for all you men out there who are not sure what they can do about this knitting scourge. How can you avoid the humiliation of having to wear a fringed purple and orange tartan sweater or a belted vest of the finest salmon-colored boucle?

PERHAPS **YOU CAN LEARN** FROM

SOMEONE ELSE'S MISTAKE.

For instance, when your wife or girlfriend is trying to make pleasant conversation and asks what your favorite Lifesaver flavor is, there are many right answers. There is also at least one extremely wrong one: "Fer Chrissakes, I don't know. All of them. Now shut yer pie-hole and get me a beer, dammit!" This man actually prefers the subtlety of Butter Rum and wishes he had politely said so. Clearly this is revenge knitting at its finest. You go, girl.

8. GRANNY SQUARES EVERYWHERE

GRANDMA'S SWEET REVENGE

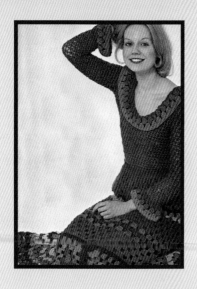

Ah, the ubiquitous granny square. What better way to insult grandmothers all over the world? And how did they show their rage over this slur on their good names? Why, by producing the very squares that besmirched them, of course. Nicely played, you sly gray foxes, nicely played. By the 1970s, legions of little old ladies were crocheting squares by the truckload in every queasy color combination possible. Bile green, dysentery brown, hematoma red, jaundiced gold, pulsing bruise blue, botulism pink—your illness was their color palette. They then set out to conquer the world, first by lulling us into a false sense of security with their quaint and cozy afghans. Once we were warm and sleepy, they unleashed their wrath, and soon the world was awash with granny squares, leaving no facet of our lives ungrannied. Luckily, their nefarious plan has fallen by the wayside over the years, but we must keep a watchful eye to be sure it never happens again. Let's take a look back at a time when the world begged helplessly, "Why, Granny? WHYYYYY?"

Even the world of fine art was swept up by the granny sensation! Rodin's

THE THINKER

was replaced in history books and museum shops everywhere with this updated version. The perkier, more pastel variation pleased the grannies greatly. Soon Michelangelo's *David* would be wearing granny-square lederhosen and the Venus de Milo would be sporting a classic granny tube top.

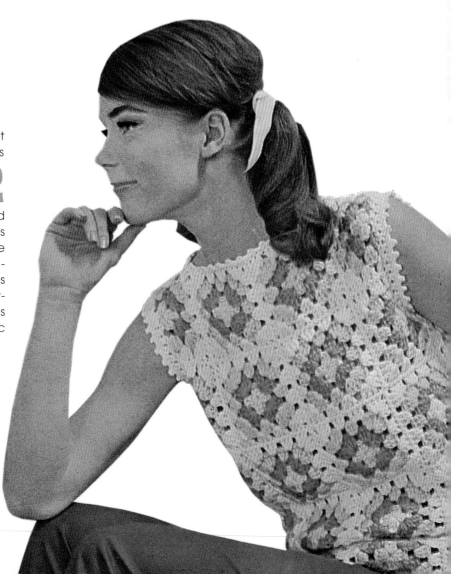

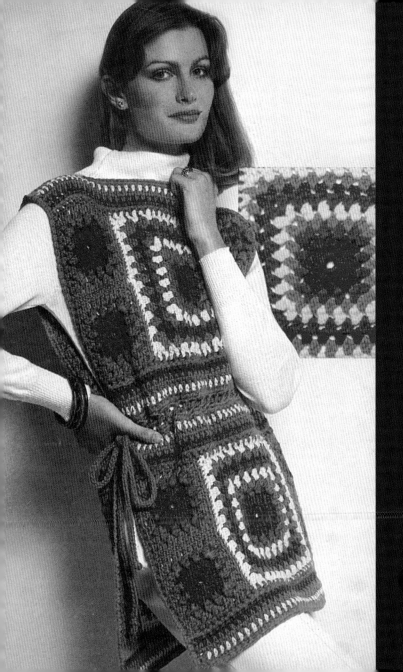

What is it with tabards? Is it for those who lack the willingness to commit to a poncho? Are wearers being groomed for an illustrious career in sandwich-board advertising? Perhaps

THE NEED TO **LOOK LIKE A** PLAYING CARD

is too overwhelming for some to deny. Whatever the case may be, it's reassuring to know that this woman is always only two string ties away from a potentially normal outfit.

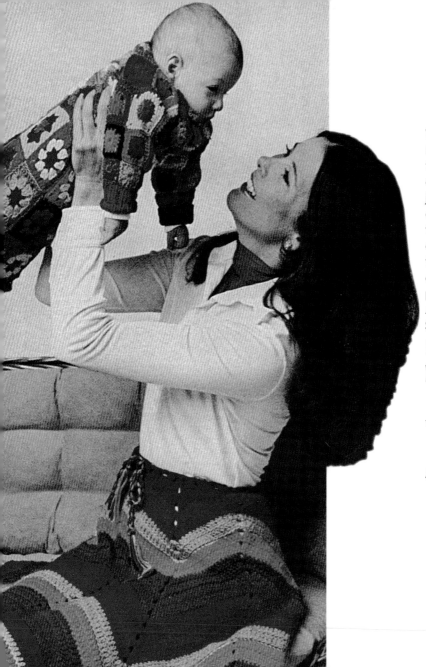

When you start life in a granny-square body bag, things can only get better, right? Right? Well, from the looks of Mommy's rainbow-rific skirt, this is just the beginning of a lifetime full of ill-conceived fashions. What does the future hold for our unfortunate cherub? I see ill-fitting ponchos and frilly jumpers, ruffled sweater vests and fringed pantsuits, belted hot pants and questionable tank tops. All handmade, all acrylic, all the time. Sometimes having these powers of **DIVINE OMNISCIENCE** IS A

TERRIBLE BURDEN

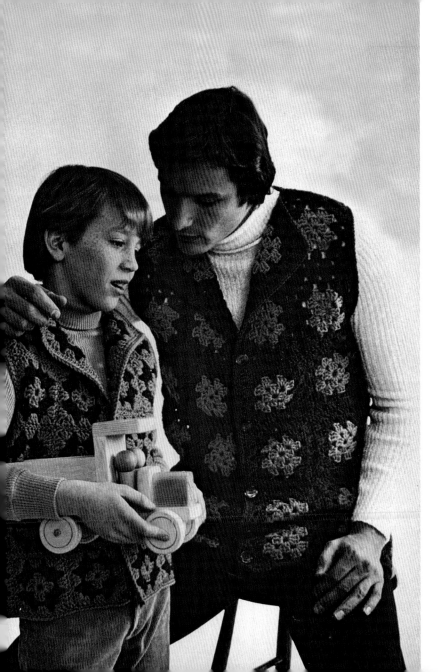

There's not much this man can say to ease his son's discontent. Why he let things get this far, he'll never know. It made such perfect sense at the time. BROWN AND TAN **SEEMED LIKE**

SUCH MANLY SHADES.

And it did seem like a great bonding experience to have nifty matching outfits. Only when it was suggested that the boy would prefer a wooden truck to a new video game did he realize something was terribly wrong. But it was too late by then. The die had been cast, the cards had been dealt, the chips had fallen where they may, and now they were both stuck wearing granny-square vests.

Bathe your home in granny good-
ness! Sit on granny, read by granny,
and protect yourself from the prying
eyes of your neighbors with granny.
Granny is your friend. Granny will help
you live a better life. Granny is good.

SURRENDER TO
GRANNY

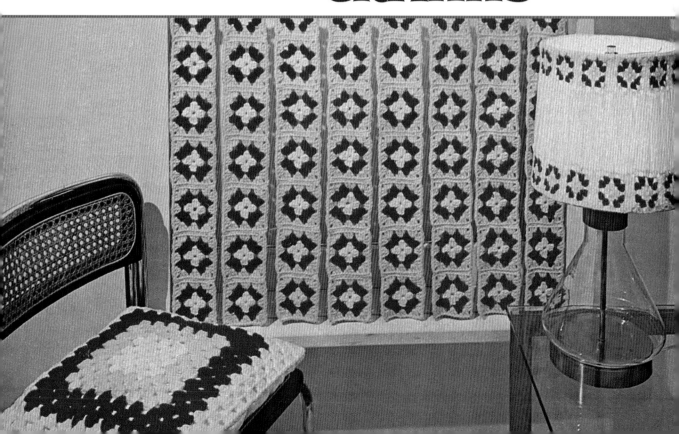

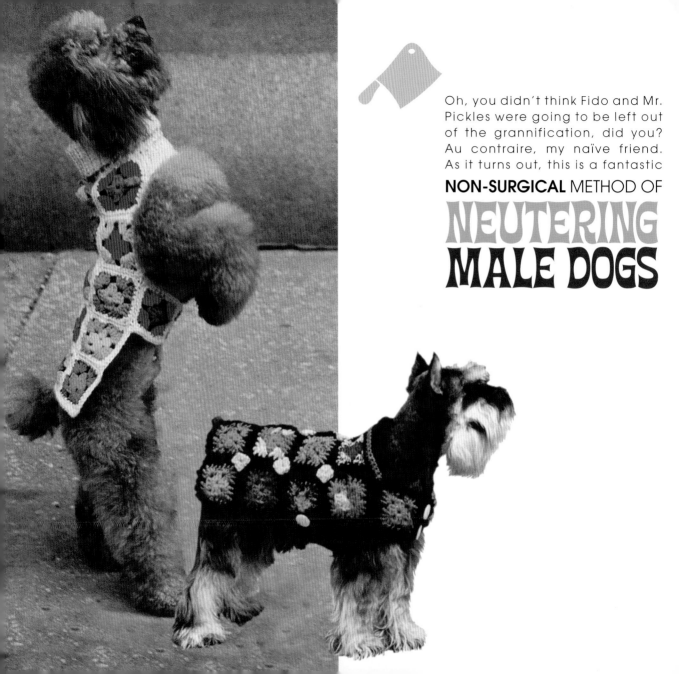

Oh, you didn't think Fido and Mr. Pickles were going to be left out of the grannification, did you? Au contraire, my naïve friend. As it turns out, this is a fantastic

NON-SURGICAL METHOD OF

NEUTERING MALE DOGS

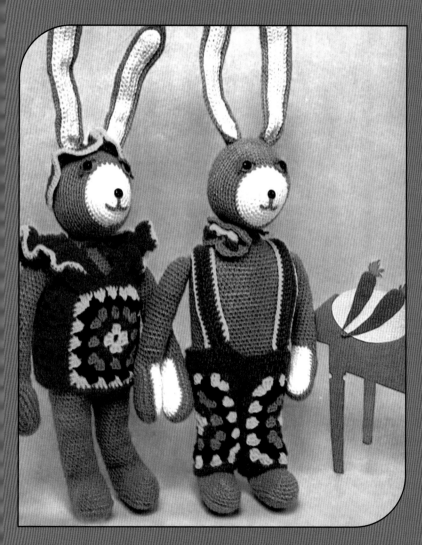

THE RABBITS ARE PERTURBED

to say the very least. They've seen a lot of hardship in their years together. From the pregnancy-test massacres to the Welsh Rabbit scare to subsisting on construction-paper carrots after their recent capture, their lives have always been made harder by humans. But as long as they have each other, they'll get through this granny-square thing, too.

And now, the grand prize winner of the prestigious Worst Idea of the Millennium Award, sponsored by the makers of Asbest-Os breakfast cereal.

I GIVE YOU: GRANNY FANNY.

The fun way to make your ass look positively monstrous. And it's a great conversation-starter. Wherever you go, people will be asking if you realize that you have a pair of potholders stuck to your derrière. The conversation-ender, of course, comes when you reply that you are "most certainly aware of it, and isn't it just the greatest?"

9. IT'S A CLOWN'S WORLD

A CREEPY PEEK AT THE CLOWNTERCULTURE OF CRAFTS

In searching for homemade Christmas gift ideas that would soothe both our crafty side and our passive-aggressive side, we made a discovery that made us sit up and shriek, "Ho Ho Holy Crap!" You see, there is a recurring theme among various craft patterns. It seems that whether you knit, crochet, sew, or just have a glue gun and some random offal lying around the house, you want to make a clown for someone. Yes, you do. You do.

Stop shaking your head and backing away and deal with the fact that because you are crafty, you want to make a clown. Just pick up any crafting magazine, and watch as the clowniness spilleth over. Some happy, some crying, some evil, some disembodied—*all wrong*. So turn that clown upside down and join us as we embark upon further exploration of the phenomenon. Please. Don't make us do this alone. We're scared.

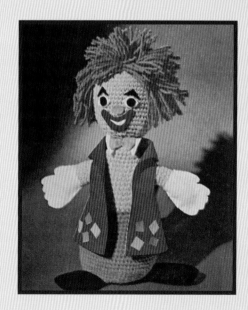

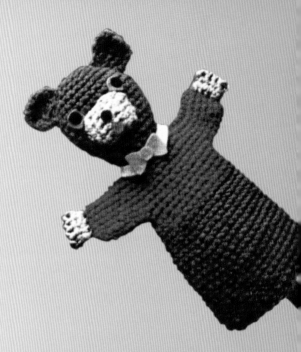
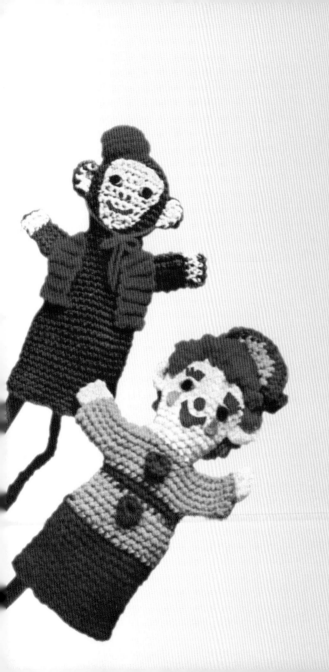

OOH LOOK!

It's Mr. Bear in his bow tie, Funky Monkey in his funny fez, and Conjunctivitis the Clown with his oozing eye infection. Let the puppet show of despair begin!

OH BOY

this is awkward. Santa hadn't seen Crumpet since the summer BBQ over at the Elves Lodge. Of all the chimneys in all the world, he had to slide down this one. How did Crumpet know he was going to be there? Well, it didn't matter. There was nothing Santa could do but try to explain why he had given the clown a fake phone number those many months ago.

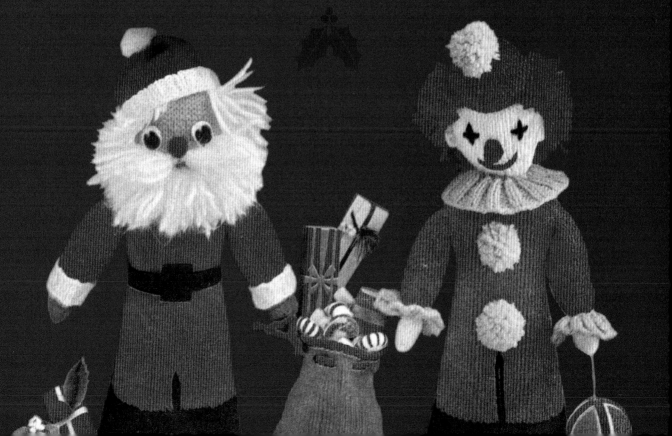

No amount of marriage counseling, whether real or from the disturbed imagination of a child, is going to help this couple. She: a sophisticated woman from Miami who enjoys a career as a real estate agent, loves nature and outdoor activities, and has a large collection of interesting shoes. He: an emotionally unhinged clown with a flowerpot on his head. Sorry—it's just not going to work out. Good thing

SHE WROTE THE LION **INTO HER**

PRE-NUP

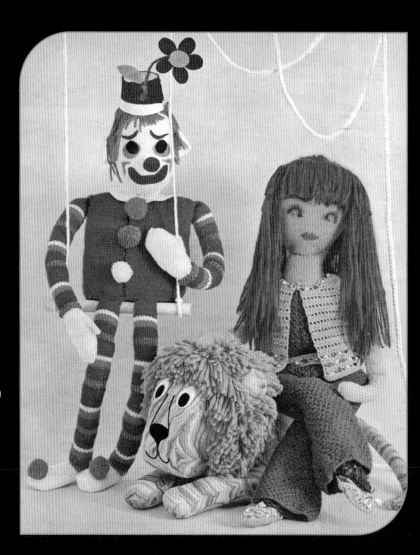

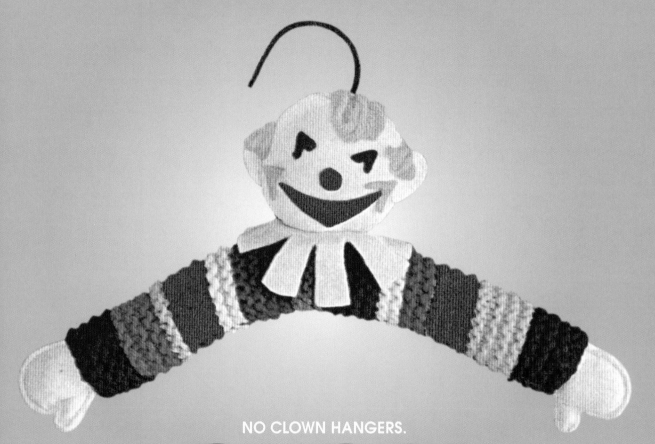

NO CLOWN HANGERS.

EVER!

After years of living in dread, little Jonathan's fear of clowns had finally been assuaged. By hunting and skinning a clown all by himself, **HE WAS NO LONGER AFRAID** AND WORE HIS

NEW PELT WITH PRIDE.

From now on, things would be different. Maybe next time his parents would take him a little more seriously when he asked for a TV with a screen that was larger than four measly inches.

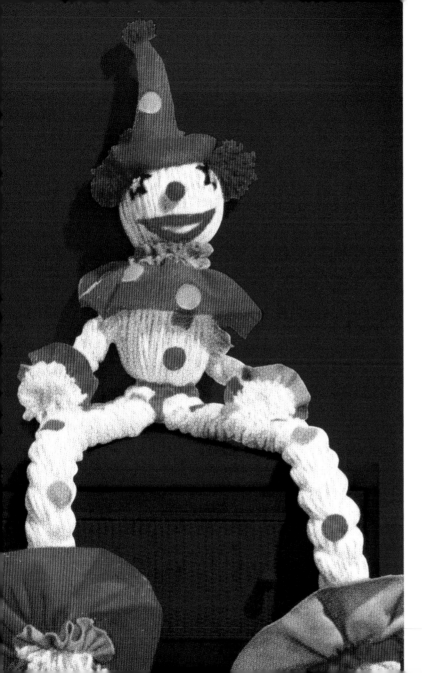

You may as well wrap a shiny new butcher knife with this li'l treasure because when he comes to life, he's just going to head straight to the kitchen to get one anyway. How else is he going to kill everyone in the house in a VIOLENT ORGY OF **BLOOD AND SCREAMING?**

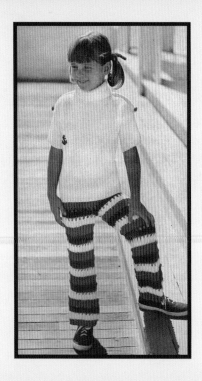

Kids. So young. So innocent. Such chumps. How else do you explain their fashion sense? If they're gullible enough to believe it when their mom claims that crocheted bellbottoms are "in," then they have only themselves to blame when she snaps a picture and shows it to their prom date ten years later. I think everyone can agree that the greatest joy of parenthood is dressing and accessorizing your very own living doll however you please. But if your folks are fashion-challenged or dress you with the passive-aggressive fury of a couple bound together only by your genetic material, well, childhood is going to sting a little.

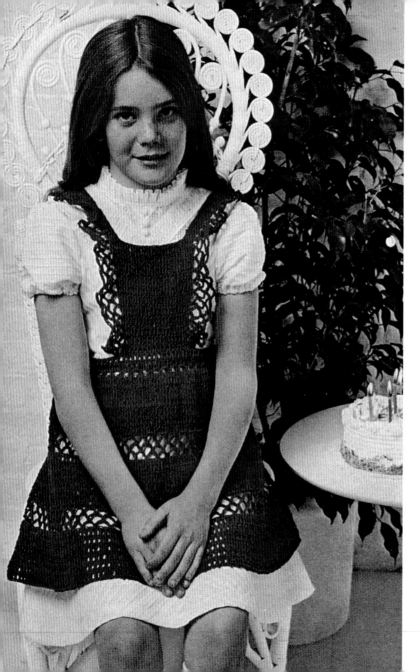

Another year, another heartache. You people have really outdone yourselves: It's been the worst birthday yet. You really shouldn't have gone out of your way with all these festive party decorations. And thank you so much for the minuscule cake that I could have baked myself using the power of a single lightbulb. Oh, except that instead of the Easy-Bake Oven I asked for, I got this swell crocheted apron. In royal blue. I can't wait to get pushed over in the playground when I wear it to school. May I please get up from this ever-so-fancy chair and table for one now? I'd like to be excused so I can go

WRITE SOMETHING SCATHING IN MY TEAR-STAINED DIARY

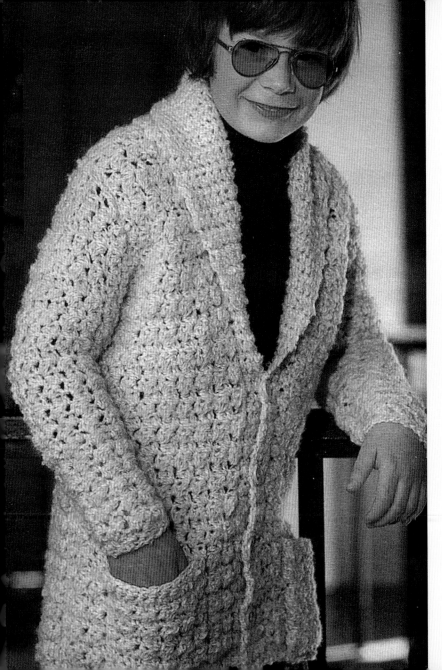

AND NOW, **WE PRESENT TO YOU**

THE VALEDICTORIAN

from the Peter Fonda School for Boys. He is this year's recipient of the Bob Crane scholarship and hopes someday to attend Jim Bakker University.

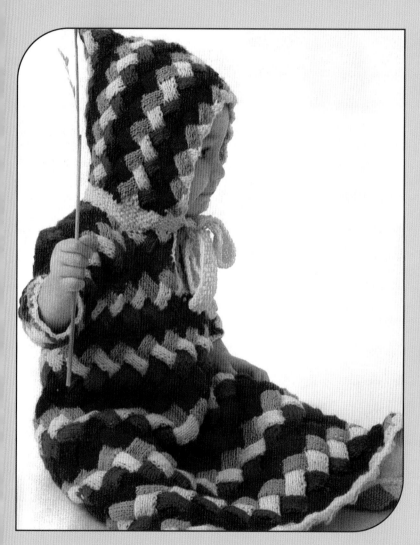

LOOKS LIKE IT'S **TIME FOR THE**

BABY PRIDE PARADE.

Get ready for the flamboyant costumes with binkies and blankies hanging out every which way, floats depicting graphic scenes of wet nursing, and the deafening chant of "We're here, we're gassy, get used to it!"

YOUTH

IS WASTED **ON THE YOUNG.**

Why not dress your kids like an elderly married couple now so they can get a jump on their golden years? Here's an utterly cheerless pantsuit to knit for him and her. Don't forget the matronly handbag and drab chapeaus! These elderly youngsters are already enjoying senior discounts at the penny candy counter, and they're so looking forward to retiring to Florida, where they will attend grammar school at a local bingo parlor. Now if only those damned neighborhood kids would just get the hell off their lawn and quit asking them to ride bikes and play tag, things would be perfect.

It's baby's first Hazmat suit! Now junior can scoop sludge at the plant just like Daddy!

WHEEE!

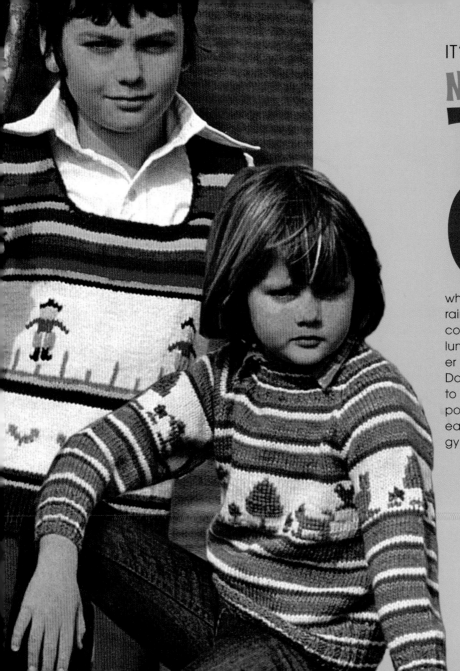

IT'S NOT EASY BEING THE
NEIGHBORHOOD
TOUGH GUY

when your mom puts you in a vest with rainbow stripes and merrily leaping cowboys. And just try stealing a kid's lunch money while wearing a sweater with . . . what are those? Squirrels? Dogs? Deer? Chupacabra? You have to carry a bigger stick, strike cooler poses, and bag more hobos just to earn half the street cred a kid in baggy pants does. No fair!

Forget time-outs. Get the soap out of that kid's mouth. Put down that list of dubious parenting techniques from the clearance bin at the bookstore and

START DISCIPLINING THE KNITTER'S WAY!

Whip up this disturbing sweater set, then simply sit back and wait for him to misbehave. You may even start to look forward to him sassing back. A few hours in the food court at the mall dodging french fries pelted by the cool kids should embarrass him into behaving. If not, at least it will make last week's living room bonfire seem almost worth it. Feel free to add mismatched velvet pants or bulk up the turtleneck, depending on the severity of the infraction and the number of house pets involved. Repeat as necessary.

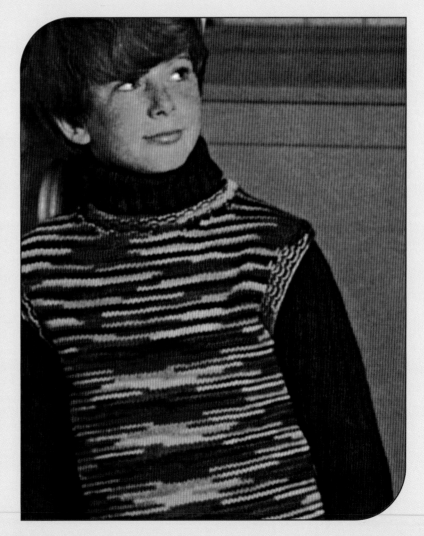

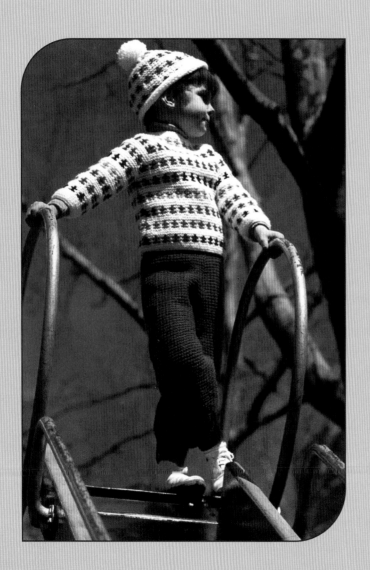

UH-OH. **LOOKS LIKE JUNIOR**

FiNALLY
GOT WiSE

to the indignities his mother has been inflicting upon him for years. He's been wearing handmade outfits since he was born, but the pantsuit has finally hit the fan. Today it ends. No more acrylic sweatpants. No more snug sweaters. No more hats to match each and every outfit. He's been standing at the top of the slide for five hours, refusing to come down until his mother can produce a bag from a *real* store containing *real* clothes. And some brand-name sneakers. Expensive ones. Ones that light up.

𝕏 HANDMADE TOYS

HOW TO PUT THE *F-U* IN *FUN!*

What makes a toy fun? How does one bring a smile to the eyes of a child? Who cares? We do have a pretty good idea about how to ruin a perfectly good Christmas morning. And putting the kibosh on birthday fun has never been easier. Even a get-well gift after a tonsillectomy provides the perfect opportunity to disappoint that special little someone. Forget about going to the store and buying presents off the shelves! Kids don't need all that plastic crap advertisers push during Saturday morning cartoons. Just dip into that bin of old acrylic yarn, and make them some plastic crap from scratch. They'll resent the mothball-scented sentiment, but hey, it's the thought that counts.

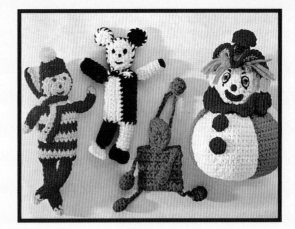

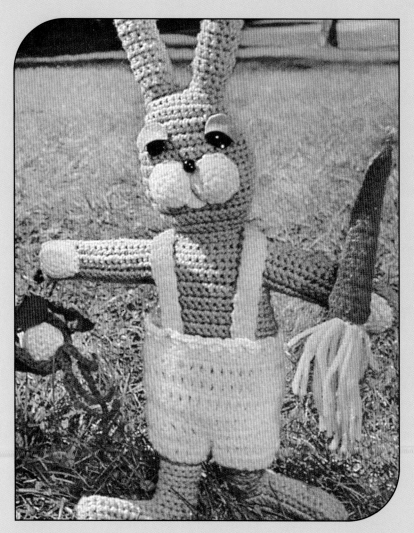

YOU KNOW WHAT THIS WORLD NEEDS?

FEWER

DRUNK RABBITS

in yellow pants ranting about the rising price of carrots and Medicare not covering the cost of his fake foot that those bastards thought was lucky—lucky for who, tell me that! And another thing, I love you man. Merry Kizzm . . . kizzmu . . . kriszzmi . . . happy birthday . . . belchhh.

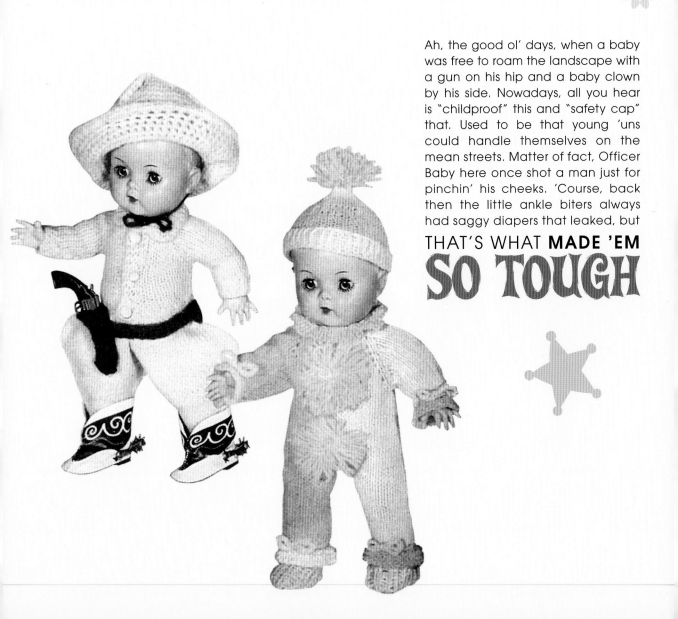

Ah, the good ol' days, when a baby was free to roam the landscape with a gun on his hip and a baby clown by his side. Nowadays, all you hear is "childproof" this and "safety cap" that. Used to be that young 'uns could handle themselves on the mean streets. Matter of fact, Officer Baby here once shot a man just for pinchin' his cheeks. 'Course, back then the little ankle biters always had saggy diapers that leaked, but

THAT'S WHAT MADE 'EM
SO TOUGH

A monk, an elephant, an African tribesman, and an Italian waiter

WALK INTO A BAR...

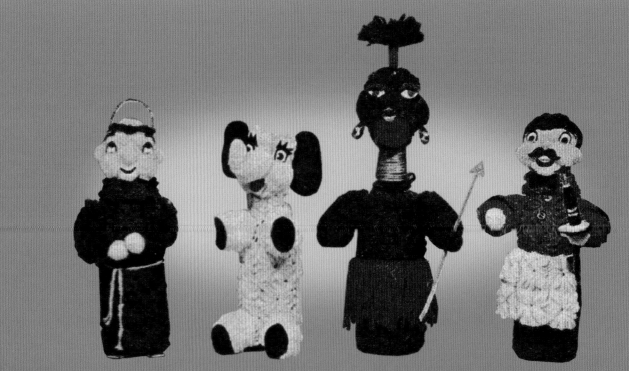

Looks like Raggedy Ann and Andy are taking a tip from Thelma and Louise and bailing out before their time is up. They've seen too many crocheted dolls before them lose their edge when newer, better dolls—store-bought dolls—show up. How could their country-bumpkin charm and clowny bad looks compete with townhouses and fashionable outfits? The short answer is that they can't. And they refuse to be left in the back of the closet with the dust mites to become weak and moth-eaten. As far as Ann and Andy are concerned,

IT'S BETTER TO BURN OUT THAN TO

FRAY AWAY

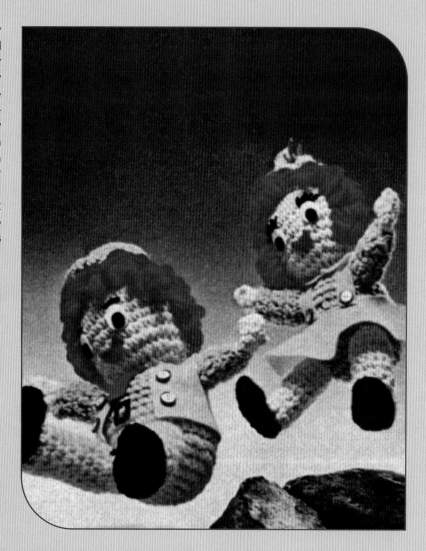

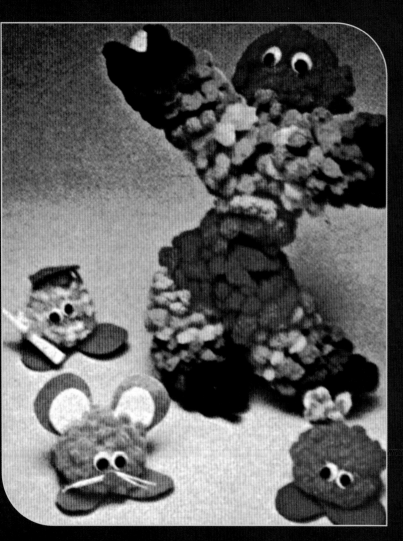

I AM THE POM-POM KING

and you lesser Pom-Poms will do my bidding! Go, my children, go into the night and bite the ankles of the unfortunate urchins who dared to receive me as a gift. They will rue the day they ever unwrapped that shiny, ribbony package, and soon their delicious souls will be mine! Mwah ha ha ha haaaaa . . .

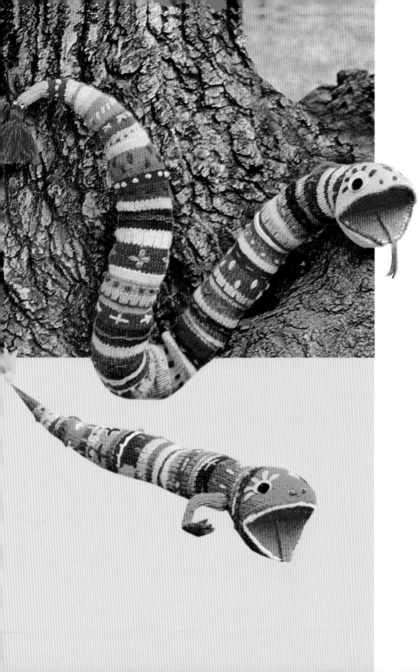

We were hesitant at first to include these

PSYCHEDELIC PSNAKES.

They're actually kind of cute. And therein lies their insidious nature. They're almost cute enough to make. And when you give one to someone, you'll do it out of genuine affection. They'll even smile and say, "How Cuuuute!" when they unwrap it. It will have prominent placement on the dresser for a while, but then it will start to be in the way. It will be moved to a shelf, but will keep rolling off because there's not enough room. It will end up unknowingly kicked under the bed, where it will marinate in dust, old tissues, and toenail clippings. When it is recovered in five years during a frantic left-shoe search, it will be briefly mourned, maybe even dusted off a bit. And then it will be included in the next yard sale. To make it easier for everyone, please attach a price tag of ten cents before wrapping to expedite the process.

As it turns out, Alfred Hitchcock spent a considerable amount of time throughout his directorial career delving into the dark world of crocheted stuffed toys.

YARN NOIR,
AS HE CALLED IT,

was rarely seen outside of private viewings and ladies' knitting magazines due to its graphic nature and psychological aftereffects. We've recently uncovered some of the least known and arguably most brilliant work of his career. We are proud to present these stills from the 1946 thriller *Knitorious* and 1954's *Dial C for Crochet*. In this tense scene from *Knitorious*, Jack stalks Jill, fetching far more than a pail of water. After convincing a pair of unemployed actors to transform themselves into the very images of Jack and Jill, the demented well-worker lures them to a remote location in the country. The scene is set with the false Jack's crown bloody and broken, his sweet "Jill" tumbling after. Having pulled off the perfect crime, everyone in

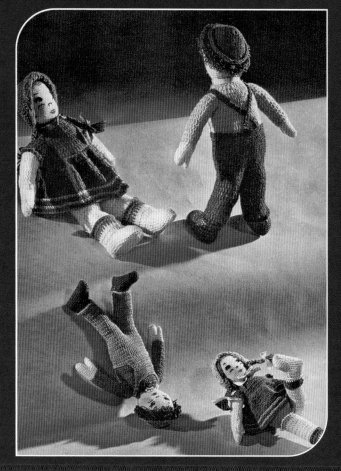

town will think the two ex-lovers have been killed in a nasty fall down the steep hill. By the time anyone figures out that the corpses are merely imposters, the real Jack will have stolen away with the now catatonic Jill into the mountains of Argentina.

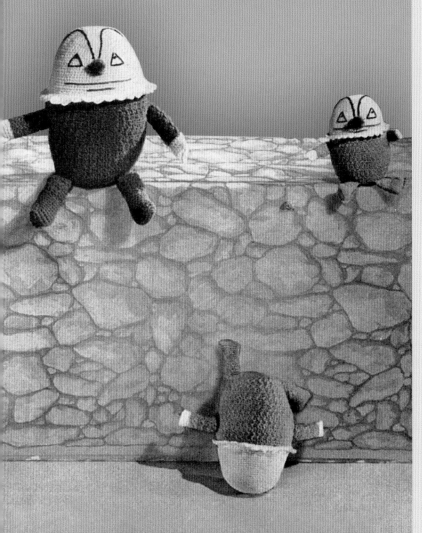

Here we see the gory aftermath of Humpty Dumpty's final dramatic plunge from the wall. But only two eggs know what really happened, and neither one of them is talking. Did Humpty experience a great fall, or

WAS HE PUSHED?

Which one of the three was really the bad egg? Will anyone be able to piece together the mystery that's shattered a community? It's a story of deceit and blackmail, masonry and royalty, equinity and humanity.

12. HOUSE OF YARN

HOME IS WHERE THE HOMELY IS

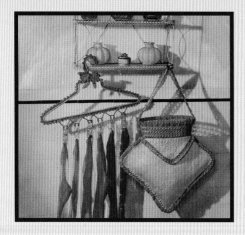

Interior design and home decor can be a source of pride for any homemaker. A woman's home is her castle, after all, and if she wants to cram every nook and cranny of said castle with useless knitted tchotchkes, more power to her! Go ahead and make outfits for the toilet paper. No one deserves a set of handmade cozies like the tissues do. So knit on, you crazy diamond. Who cares if the last crocheted trivet you made melted to the bottom of the casserole dish? Forget that the kids are getting seasick from the psychedelic afghans you made them. And if your husband complains about the 40,000 volts of static electricity coursing through his body from living in a yarn-encrusted house, kindly refer him to the chapter of this book titled "Emasculation Nation" and go about your business.

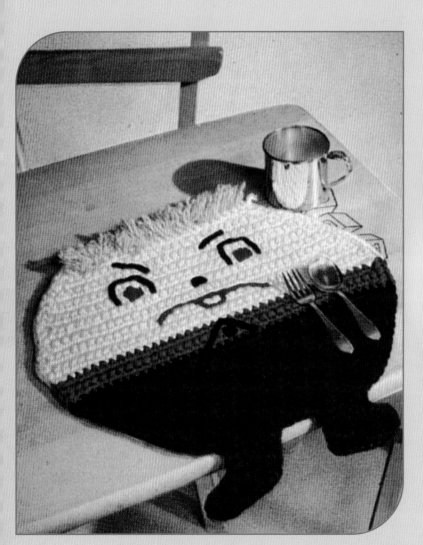

Looking for a placemat? One that says "Screw you *and* your lousy breakfast!?" Here you go.

IT'S HUMPTY DUMPTY, AND

BOY IS HE PISSED.

Imagine if you fell off a wall and were so gravely injured that not even the king's horses could do a damned thing. And then some twit comes along, splays you out, leaving your twisted and broken legs dangling, then has the nerve to lay a place setting on your cracked, yolk-covered body! Screw you, indeed!

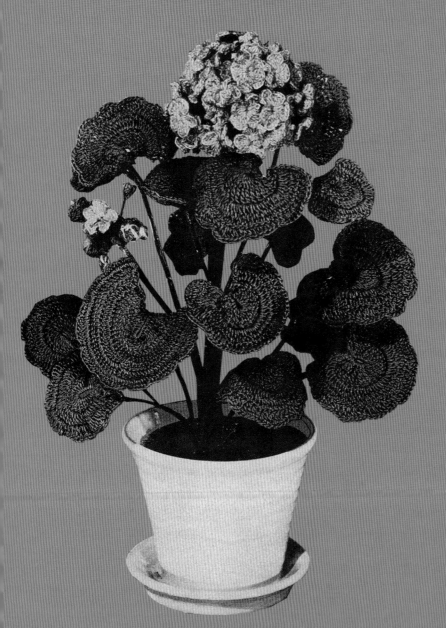

Live things are overrated, and that's why

CROCHETED PLANTS ARE PERFECT.

No challenge, no trying, no trying to try, no growth, no responsibility, no sense of accomplishment, no death. Isn't that how life should be? Would anyone care for some coffee?

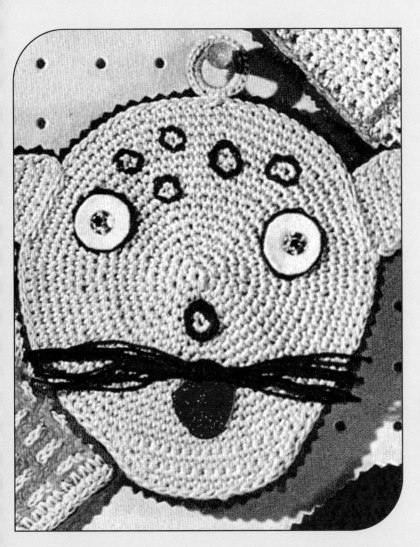

Why, it's Lenny the Leopard, and it looks like he's soused again. You can tell by his glassy-eyed stare and bloated, protuberant tongue. For a potholder, HE CAN **REALLY HOLD HIS**

LIQUOR.

Go ahead, pick up a hot pan with his face—he won't mind.

Capture the joy of a well-executed Dutch oven with this delightful baby blanket featuring

GASSY RABBIT

AND HIS BROTHERS **SMELT IT AND DEALT IT.**

Here's another one of those insidious items you may find yourself inexplicably drawn to. It's OK to admit out loud that at one point in your life, perhaps even this very point right now, you would have loved a

HamBURGER SANDWICH
PiLLOW Set.

It seems as if everyone fell head over heels for the lovable hamburger in the '70s. People bought gum shaped like tiny cheeseburgers. The local pastry shop had a burger-shaped donut displayed proudly in the front of the case. I even had a book full of hamburger jokes. No doubt about it: Grind up a cow and throw it on a bun, and people will go ga ga over it. However, I guarantee you that every kid who begged for one of these until their mother relented ended up sorely disappointed. By the time the dust had settled, all they got was the finished bottom bun and meat patty pillows, half of an unstuffed cheese, a bag full of yarn that never fulfilled its destiny, and a twitchy mother. No one in the world ever made it as far as the tomato, much less the pickle. Of this, I am certain.

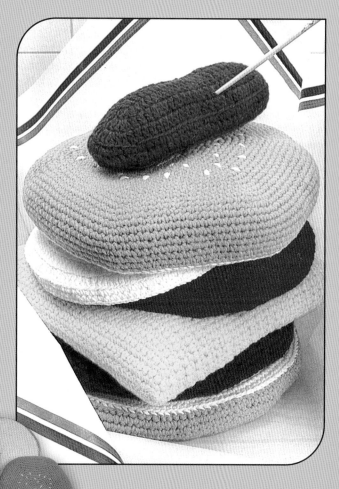

DON'T TELL ME THAT THE
SALAD-SERVING UTENSILS

RUN AROUND
NAKED

and free at *your* house. Shocking!

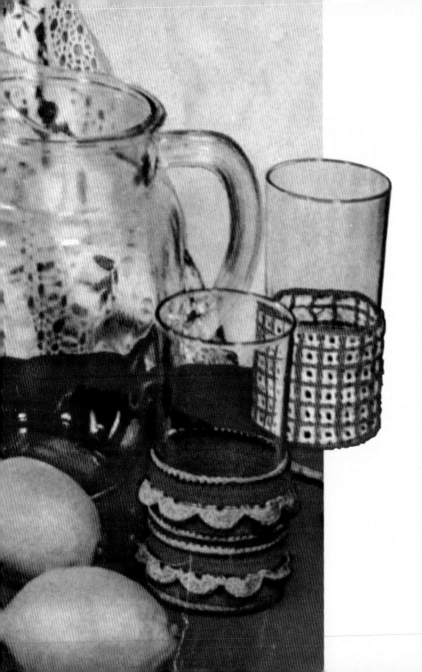

Is this a kitchen or a nudist colony? First your serving utensils are caught streaking like drunken frat boys, and now your drinking glasses are **STRUTTING AROUND** LIKE A

GAGGLE OF BiMBOS

at Hef's mansion. What would your neighbors think of your kitchen of ill repute? When you're done knitting underwear for the cups, you might want to do something about those slutty pots and pans.

Designing an entire room based on a granny-square afghan may seem crazy, but it was the sanest Gladys ever felt. When the pink, purple, green, and blue window treatment was finished, she had finally realized her vision. She knew then that she was unstoppable and would achieve her goal of knitting a house-cozy large enough to cover the exterior of their modest home. **SOON** THEY WOULD LIVE IN A

GRANNY RANCH

and everyone in the neighborhood would know who wore the pants in this family.

Special Bonus Patterns

We at the Museum of Kitschy Stitches know better than to encourage the misuse of perfectly good acrylic yarn. That's why we'd like you to engage in some good old-fashioned acrylic abuse! *The Museum of Kitschy Stitches* is proud to present a pair of exclusive patterns for the Kitschy Kouple on the go. And if you're single, these babies will help keep it that way! Enjoy these patterns responsibly.

Grannify yourself with this roomy tote bag that's sure to garner placating nods and tenuous smiles from friends and strangers alike. A large button accents the beauty of this piece, as do a dizzying array of stripes, tassels, pom-poms, and a braided cord! Getting through the airport with granny in hand should be a breeze. If the security personnel are really looking out for your best interests, they'll deposit it immediately in the nearest trashcan.

And what dapper gent wouldn't want to be caught dead in this spiffy tie? Worn correctly, this handsome neckpiece should ensure at least three feet of personal space at all times, and you'll never again be bothered by the kindness of strangers. No one *ever* helps a freak in a tie of this magnitude. And say goodbye to the annoyance of actually having to tie it, because this bad boy is a clip-on! That's right, it's made with 100 percent imitation Windsor Knot! No coordination required!

The Grin and Bear It Granny Square It Bag

--

FINISHED DIMENSIONS: 19.5 x 14 x 2.75 inches (49.5 x 35.5 x 7 cm)

Supplies:

• One skein each of the cheapest, squeakiest acrylic yarn you can bear to be seen buying. To achieve grannirvana, combine colors with reckless abandon. (We used Red Heart Super Saver in 0320 Cornmeal, 2335 Taupe, 2254 Persimmon, 0528 Medium Purple, and 0661 Frosty Green.)
• Size H/8 (5.00 mm) crochet hook
• Tapestry needle

Adornments (optional):

• Use pom-pom and tassel-making templates. *For extra points, recycle adornments from previously unloved knitwear.*
• One large, VERY LARGE, button

Lining (optional):

• 2 yards (1.83 m) of lining fabric
• 3 large pieces of white plastic canvas
• Needle and thread

Stitches:

Ch: Chain Stitch
Sl: Slip Stitch
DC: Double Crochet
SC: Single Crochet

Granny Square:

We made two different color combinations. Feel free to mix it up as much as you want. Go overboard. It's what granny would have wanted. The colors work from the center out.

Square 1 color scheme is Purple (A), Brown (B), Yellow (C), then Orange (D).

Square 2 color scheme is Brown (A), Orange (B), Green (C), then Purple (D).

You will need to make 6 of each square for a total of 12 granny squares.

Row 1: With color A, ch 4. Sl in first ch to form a ring.
Row 2: Ch 3, 3 dc in ring, ch 4, (4 dc in ring, ch 4) x 3, sl into top of ch 3 from beginning of round. Cut yarn and pull through loop.
Row 3: With color B, ***4 dc in one of the ch 4 loops, ch 4, 4 dc in same ch 4 loop, ch 2*** repeat from * to * in the remaining ch 4 loops from previous row. Sl into first dc. Cut yarn and pull through loop.
Row 4: With color C, ***4 dc in one of the ch 4 loops, ch 4, 4 dc in same ch 4 loop, ch 2, 4 dc in next ch 2 space, ch 2*** repeat from * to * around square. Sl into first dc. Cut yarn and pull through loop.
Row 5: With color D, ***4 dc in one of the ch 4 loops, ch 4, 4 dc in same ch 4 loop, ch 2, (4 dc in next ch 2 space, ch 2) x 2*** repeat from * to * around square. Sl into first dc. Cut yarn and pull through loop.

Voilà, a finished square! After completing all 12, have a stiff drink and come to terms with the fact that you just crocheted a dozen granny squares. Weave in ends.

Arrange and seam 4 rows of 3 squares each using the Crochet Seam technique below.
Alternate squares 1, 2, 1, then squares 2, 1, 2.

Crochet Seam:

Holding two pieces with the wrong sides facing each other, sc into rightmost stitch of both pieces at the same time. Repeat across entire edge to be seamed.

On all strips, work the following on both the top and bottom edges:
Sc across long edge with yellow yarn. 78 sc total (one stitch in every stitch).
Ch 1, turn, sc across long edge with same color.
Cut yarn, pull through loop.
Switch to brown yarn, sc across long edge with brown yarn. Cut yarn, pull through loop.

You now have 4 strips with rows of yellow and brown stripes along both long edges. It's only a matter of time until you're walking around town with this thing!

Use the Crochet Seam to attach two alternating strips along one of the long edges. Repeat with remaining two strips. The front and back are now complete!

Bottom (make 1):

With orange yarn, ch 79.
Sc in second ch from hook. Sc in every ch after that for a total of 78 sc.
(Ch 1, turn, sc in every sc) x 9 for a total of 10 rows of sc not counting original ch row.

Use the Crochet Seam to seam bottom between front and back along long edges.

Sides (make 2):

With yellow yarn, ch 65.
*** Sc in second ch from loop, sc in all remaining ch for a total of 64 sc. Cut yarn, pull through loop. Switch to brown yarn and work 2 rows of sc. Cut yarn, pull through loop.***

Repeat * to * along other side of original ch 65 row.
Cut yarn and pull through loop.
Switch to yellow yarn, work 2 rows of sc on both brown stripes.
You should now have 10 total rows of sc, 5 stripes, alternating yellow and brown.

Use the Crochet Seam to seam sides to front back and bottom. It's too late to turn back now. You may as well make the straps.

Straps (make 2):

Ch 76 (or preferred length) with yellow yarn.
Sc in second chain from hook and all remaining ch for a total of 75 sc.
Cut yarn, pull through loop.
Switch to brown yarn, sc in every sc.
Cut yarn, pull through loop.
Repeat with brown yarn on other side of original ch row.
Sew each strap into place so that it spans the width of the center granny square for sturdiness.
See image on page 126 for placement. Weave in any ends.

Adornments (optional):

Make 1 large green and 2 small pom-poms.
Make 4 brown tassels with a yellow wrap.
See image on page 126 for placement.
Cut 9 strands of brown yarn about 20 inches (50.8 cm) long.
Divide into 3 groups of 3 and braid until a few inches from the end. Separate into 3 groups of 3 strands and braid the remaining length.
Attach 1 pom-pom to each little braid.

Alternatively, go through your closet and snip every pom-pom, tassel, and dangly cord off everything you own and attach it to your brand-new eyesore.

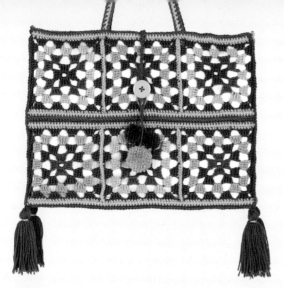

Lining:

Cut plastic canvas to the same dimensions as each front, back, side, and bottom piece.

Cut 2 pieces of lining about 2 inches (5 cm) larger than each of the pieces.

Place a piece of lining, then the plastic canvas, then another piece of lining together. Pin and sew tightly against the edges of the plastic canvas on all sides. Repeat for all pieces. Sew lining pieces together so that raw edges appear on the side that will be facing out. Trim raw edges so they won't peek through to outside of bag.

Tack lining to inside of bag at bottom corners. Sew top edge of lining to top of bag, along the yellow or brown stripes.

Now you've gone and done it. You have willfully and knowingly created your very own kitsch. Suppress that gag reflex—ignore that nagging urge to flee. Now go out there and show the world what you've got, Granny!

Clippy Cravat

--

Supplies:
- Less than one skein each of Green (color A), Orange (color B), and Purple (color C) worsted weight acrylic yarn. Surely there's some stashed in a plastic bag under your bed.
- Size US #9 (5.5 mm) knitting needles
- Size US #7 (4.5 mm) DPNs
- Size G (4.00 mm) crochet hook
- Tapestry needle
- Optional: Clip-on tie hardware

Gauge: 20 stitches x 26 rows = 4 inches (10 cm)

Stitches:
K:	Knit
P:	Purl stitch
Sl:	Slip
Dec:	Decrease
Inc:	Increase

Tie:
With color A, cast on 2 stitches.
Working in stockinette stitch, increase at both ends of every row until you have 20 stitches.
End on a wrong side row.

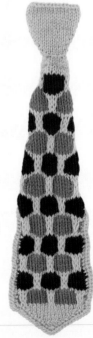

Row 1: With color B, k1, sl2, k6, sl2, k6, sl2, k1.

Row 2: P1, sl2, p6, sl2, p6, sl2, p1.

Rows 3–6: Repeat rows 1 and 2 twice more. Cut yarn.

Row 7: With color A, knit.

Row 8: Purl.

Row 9: With color C, k5, sl2, k6, sl2, k5.

Row 10: P5, sl2, p6, sl2, p5.

Rows 11–14: Repeat rows 9 and 10 twice more. Cut yarn.

Row 15: With color A, knit.

Row 16: Purl.

Repeat these 16 rows 5 more times. (Adjust length for desired ridiculousness.)

Work one more row straight (should be a right side row).

Do not bind off or cut yarn. With crochet hook and color A, single crochet (sc) down left side of tie. When you reach the first corner at the bottom, work 3 sc in same spot. Work sc evenly to point of tie. Work 3 sc in point of tie, work sc evenly to next corner, work 3 sc in corner, work sc evenly up other side of tie.

Chain 1, turn.

Sc in every sc. Work 3 sc in same corners as previous row. Still do not cut yarn.

Move all live knit stitches to a DPN.

Pick up one stitch along top edge of sc on right side of row.

Knit across remainder of the live stitches.

Pick up one stitch along top edge of sc on left side of row (22 stitches total).

Find a mirror and hold the work-in-progress up to your neck. Congratulate yourself on adding to the world's problems.

Place 5 stitches from each end onto a separate DPN (3 DPNs total).

Fold outer DPNs behind center DPN. This will turn the outermost stitches toward the center back of the piece.

Now, with public side facing you, knit one stitch from the front DPN with one stitch from the needle right behind it. Two stitches will be knit together as one.

Repeat for the next 4 stitches. The back right DPN should now be empty.

K2 stitches normally from just the front DPN.

Knit one stitch from the front DPN with one stitch from the needle right behind it.

Repeat for the next 4 stitches.

You should now have 12 stitches on a single DPN.

Dec 1 stitch at both ends of next 2 rows until 4 stitches remain.

Work straight for an inch (2.5 cm). Bind off, cut yarn.

Faux Knot:

With Color A, Cast on 10 stitches.

Inc 1 stitch at beginning and end of every other row for 17 rows.

Bind off, cut yarn.

Finishing:

Sew knot to tie.

Fold back top corners of knot and secure in place.

Sew on tie clip.

Instead of a tie clip, you could make a neck band with ribbon and snaps. Or double the ugly! Keep knitting until the tie is 60 inches (1.5 m) long and can be tied in a classy Windsor knot. Be creative; it's not like you're going to actually make the tie look any worse!

—Patterns by Marnie Maclean

STITCHY McYARNPANTS is the creator and curator of the Museum of Kitschy Stitches. With a Ph.D. in Kitschology and a minor in Cheeky Snark, she is highly trained to document the fashion foibles of our past. Her questionable style of dress in the 1980s may also someday allow her to have an exhibit of her own. Stitchy shares a home with her darling husband, a small herd of cats, *and way too much kitsch.*

Visit the Museum of Kitschy Stitches on the web (**www.museumofkitschystitches.com**) for additional exhibits, patterns, and more!